IMAGES
of America

BRIELLE

IMAGES
of America

BRIELLE

Union Landing Historical Society

ARCADIA
PUBLISHING

Published by Arcadia Publishing
Charleston, South Carolina

Printed in the United States of America

Library of Congress Catalog Card Number: 2007927702

For all general information contact Arcadia Publishing at:
Telephone 843-853-2070
Fax 843-853-0044
E-mail sales@arcadiapublishing.com
For customer service and orders:
Toll-Free 1-888-313-2665

Visit us on the Internet at www.arcadiapublishing.com

For the greatest catches in our lives who supported us "book," line, and sinker. We hope this book serves as an inspiration to all readers to embrace and preserve the legacy of our rich heritage.

CONTENTS

ACKNOWLEDGMENTS

This project would not have come to fruition without the collaboration of many individuals. I am most grateful to my wife Suzanne and two children, Indigo and Miles, for their patience, love, and support throughout this project. I am also deeply indebted to my fellow committee members for their hard work and dedication to our project: Betty Anderson, John Belding, E. David DuPre, Gail and Ray Herbert, Natalie and Richard Holmquist, and Janice Wurfel.

The foundation of this work was laid in the society's first publication *Union Landing Revisited*. We continue the work of those society members who embarked on the mission to preserve and record the history of Brielle. I would also like to acknowledge the contributions of many other individuals and groups: Barbara Reynolds and the Squan Village Historical Society, the Archives of the Borough of Brielle, Sherry Hopkins, Borough Administrator Tom Nolan, Councilman Timothy Shaak, and the Brielle Fire Company, Councilwoman Ann Scott, the Brielle Chamber of Commerce, Catherine "Kit" Shirley Canning, Janet Hendricks and the Hendricks family, Ginnalee Pharo, David Wurfel, the Bogan family, Capt. Bob Matthews, the Harms family, Marguerite "Peg" Beckett, Judy Prestia, the John Geiges family, Hank Dolche, Robert Heras, Frank Keigher, Robert J. Collinson, Marylin and Robert Sauer, Jane Underhill Speicher, Carole Wall, Mette Hegna, and my star proofreaders Judie and Joe Entwistle. Without their generosity in lending and donating photographs and archival materials, sharing their experiences, and recognition of the importance of preserving the past, this book would not have been possible.

Lastly we are all indebted to the legacy of the late Helen Dennett Holmquist, who in 1962 compiled and published the first written history of Brielle.

Raymond F. Shea
Book Committee Chairman
Union Landing Historical Society
www.briellehistory.org

INTRODUCTION

Union Landing was the first name given to the corner of Monmouth County that would become Brielle. Union Landing's maritime history predates the incorporation of Brielle as a municipal entity in 1919, the Civil War, and even the American Revolution. Its location less than a mile from the mouth of the Manasquan River's opening to the Atlantic Ocean provided an ideal spot for a protected harbor and a transfer point for goods on the overseas shipping routes from New York, Philadelphia, and beyond. During the course of the American Revolution, the British embargoed salt imports to the colonies from the Caribbean islands. As a defensible source of salt water, Union Landing was a key source of salt production. In those days before refrigeration, salt was a vital food preservative. After the Revolution, Union Landing flourished as an early-American seaport and center of the "coasting trade," the transport of goods over short, overseas route segments. Goods were transferred to and from the overland routes at Union Landing's long wharf.

The entry of the railroad connecting the Brielle area to New York and Philadelphia diminished the importance of maritime shipping routes but opened an entirely new opportunity—tourism. Businessmen from New York and North Jersey established a seaside development in the area and began to sell vacation homes. The abundance of windmills used for pumping fresh water from underground aquifers reminded one of the developers of a recent trip he had taken to Brielle, Holland—hence the name Brielle was given to the new development. With tourists and vacationers came the recreation industry; beaches provided bathing and easy access to the river, and the ocean provided recreational boating, sailing, and fishing. Hotels and resorts flourished from the 1870s well into the 20th century.

When Brielle seceded from Wall Township in 1919 it was an established center for vacation and tourism in New Jersey. With the passage of the Volstead Act in 1919, the United States government banned the sale and transport of alcoholic beverages within its borders. Inevitably some chose to circumvent the law and enable the flow of liquor. Again Brielle's location made it an ideal spot for this profitable, although illicit, business. Despite national prohibition, New Jersey was widely regarded as a wet state and many gallons of illegal liquor passed through Brielle on the route from "Rum Row," three miles out on the Atlantic, to the speakeasies and clubs in the New York, New Jersey, and Pennsylvania area.

In 1925, the Manasquan River was connected to Barnegat Bay by the Point Pleasant Canal, establishing an easy, inland water route from Brielle to points south. It also encouraged the silting over of the Manasquan Inlet, thereby impeding access to the open ocean. In 1931, with the cooperation of the state and federal governments and the municipalities of Brielle,

Manasquan, Point Pleasant, and Point Pleasant Beach, a project to permanently reopen the Manasquan Inlet was begun. Stone jetties were constructed on the north and south sides of the inlet to create a permanent opening to the ocean. The stones were excavated from the new Sixth Avenue IND Subway project in Manhattan. The large boulders were transported from New York City by flatbed truck to the construction site. Brielle's position as an ocean access point was firmly established.

With permanent access to the ocean insured, Brielle was in a favorable position for development of the fledgling charter fishing boat industry. Over the next 10 years, a fleet of deep-sea fishing boats amassed in Brielle offering day trips to inshore fishing spots as well as longer excursions to fishing spots far out in the Hudson Canyons. Along with the fleet of boats for hire came privately owned vessels of fishing enthusiasts from all over the country and even the world. The personalities and stories of the individual anglers ran the gamut from bottom boat passengers out for a day of fishing to the husband and wife angling team of Lou and Eugenie Marron, whose record-setting swordfish catches in the late 1950s remain unbeaten today. Major fishing tournaments were based in Brielle and drew participants from all across the nation and the world. Exploits of Brielle anglers were recorded in fishing journals and sporting magazines around the globe.

Brielle flourished as a major sportfishing center through the 1960s, but overfishing the waters of the North Atlantic by commercial interests led to the gradual decline of the fish population. With that began the decline of the fishing industry here. Little by little the charter boat fleet diminished. Private vessels left Brielle's marinas for warmer climates and more plentiful fishing grounds. By this time, Brielle was an established suburban residential community, so the waning of this industry did not have the same effect in the community as the decline of industries like the steel mills of Pennsylvania or the textile mills of northern New Jersey. In fact, Brielle was in a continuing cycle of growth both in population and in residential development. Rural areas like Brielle have become thriving suburbs since the completion of the Garden State Parkway in 1957 due to the easy highway access to business and industrial areas in the north.

Brielle's status as one of the wealthier communities in Monmouth County and its location with a significant amount of waterfront property insured the presence of a larger than average number of recreational boaters. Even though the fishing was not as plentiful as it used to be, scores of anglers continued to use Brielle as a home port throughout these lean years.

Despite the decline of fishing, Brielle has continued to thrive as a community. The fish populations have begun to surge in recent years. There is some debate whether the resurgence is due to government regulation or the natural ebb and flow of fish populations. In any event, sportfishing activity is again on the rise in Brielle. Large private fishing vessels are returning to Brielle's marinas, and the number of small six-passenger charter vessels, known as "six-packs" in the trade, is steadily increasing. It is unknown whether the fleet will become as large as it was in the 1950s.

One

EARLY LAND
DEVELOPMENT

In the late 1800s, Union Landing, as Brielle was known in those days, was still a part of Wall Township and consisted mainly of farms. The rise of railroads had diminished the importance of the coasting trade, the seagoing transportation mode for which Union Landing was a center. There was no industry to speak of and roads were primitive at best. Union Landing was a remote location on a riverbank connecting to the open ocean. The ideal place to build a seaside retreat. These were the thoughts of Messrs. Turner, Bacot and Behringer, three principals of the newly formed Brielle Land Association. Having purchased 150 acres of land east of the present Route 71, they laid out individual building lots on three streets—Magnolia, Park, and Woodland Avenues. Presumably as a part of their plan, the tract was bisected by a branch of the recently constructed New York and Long Branch Railroad. The developers wisely donated a parcel of land to the railroad company for the purpose of building a railroad station. A regular station stop on this line enabled easy access to and from New York, Philadelphia, and all points in between. In those days, one could travel south and then west on the railroad all the way to Philadelphia. They gave the name Brielle to their seaside resort because one of the developers thought the windmills reminded him of Brielle, Holland, where he had recently vacationed.

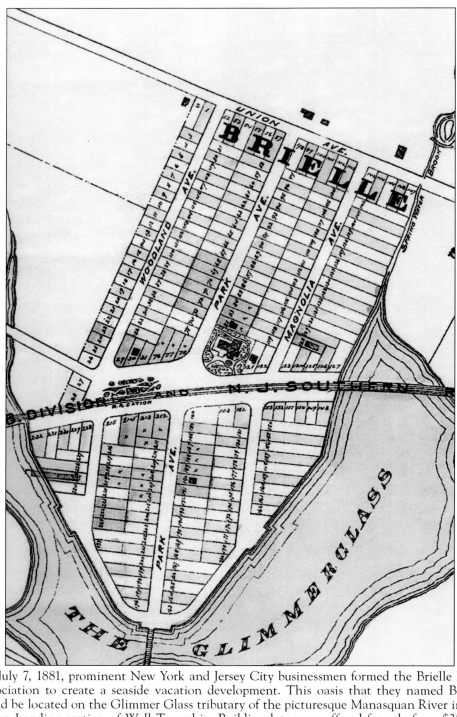

On July 7, 1881, prominent New York and Jersey City businessmen formed the Brielle Land Association to create a seaside vacation development. This oasis that they named Brielle would be located on the Glimmer Glass tributary of the picturesque Manasquan River in the Union Landing section of Wall Township. Building lots were offered for sale from $250 to $500 depending on size and location. The streets of the early development are now located east of Route 71 (Union Avenue).

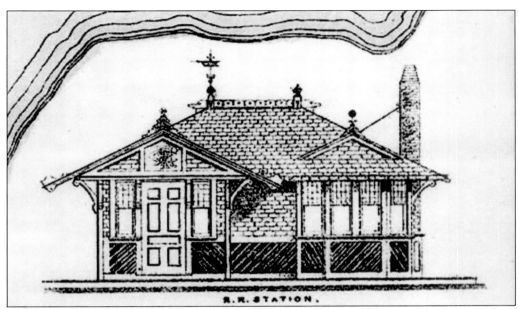

The Brielle Land Association prepared this sketch of the proposed rail station that would enable convenient access from New York and Philadelphia to the new vacation development. Land for the station was donated to the New York and Long Branch Railroad by the land association in exchange for making it a scheduled stop on the line. Easy rail access to Brielle from New York and Philadelphia would have been a key selling point for the lots.

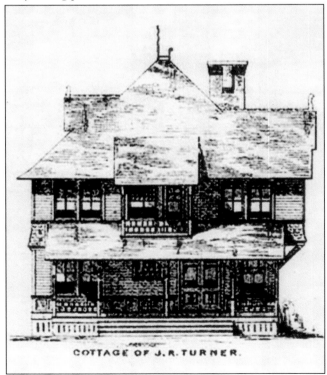

An artist's rendition shows one of the stick-style cottages that would become part of the Brielle Land Association development. This cottage in particular was being designed and built for one of the developers, J. R. Turner. Prospective buyers could choose their cottage from a few different models. Two of these cottages still stand today, one as a year-round home on Fisk Avenue and the other on nearby Brielle Avenue.

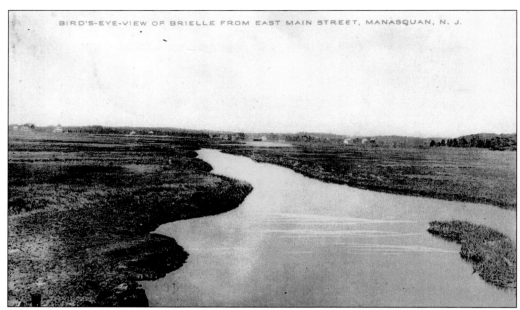

BIRD'S-EYE-VIEW OF BRIELLE FROM EAST MAIN STREET, MANASQUAN, N. J.

This bird's-eye view is looking south from East Main Street, Manasquan, into neighboring Brielle. Years later, this area would become a busy fishing and boating center. Shown in the distance off to the right is Capt. Henry Green's farm, which was located in the area of what is now Crescent Drive.

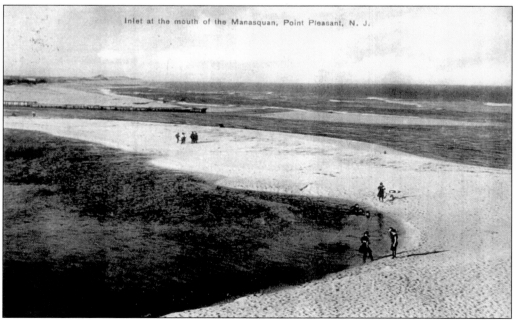

Inlet at the mouth of the Manasquan, Point Pleasant, N. J.

This photograph is looking south from Manasquan toward Point Pleasant Beach. Shoals and sandbars in the river moved frequently over the years. At the time of this photograph the inlet had not yet been fixed in its current position.

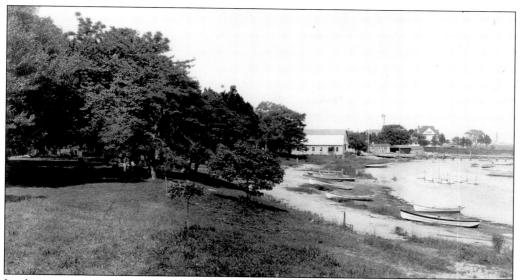

In the summer of 1910, this was the calm and peaceful appearance of the Manasquan River shoreline. Vacationers from New York, Philadelphia, and North Jersey could look forward to restoring their strength and vitality here. In addition, the scenery was picturesque enough to attract a significant school of impressionist artists in the late 19th and early 20th century who later became nationally recognized, including Thomas Eakins, Theodore Robinson, Charles Freeman, Will Low, Wyatt Eaton, and Albert Reinhardt. The white building pictured is Bart Pearce's boathouse.

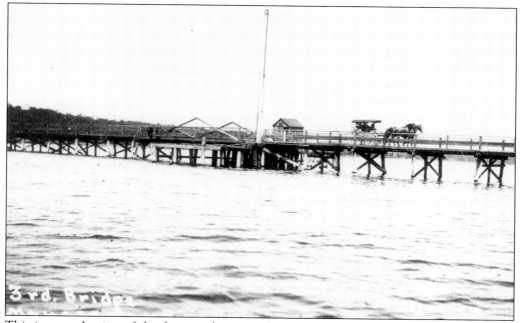

This is an early view of the first wooden swing bridge, which spanned the Manasquan River between Bridge Avenue in Brielle and Bridge Avenue in Point Pleasant Beach. The horse and carriage is traveling from what was to become Brielle toward Point Pleasant Beach. Bridge Avenue in Brielle was later renamed Higgins Avenue.

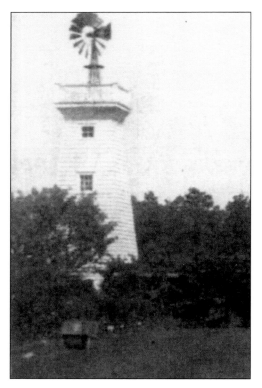

The Brielle Land Association decided on the name Brielle for its new vacation development. The windmills that dotted the Manasquan River shoreline reminded a developer of the area around Brielle, Holland, where he recently vacationed. The windmills here were used to pump water from the same underground aquifers that some of Brielle's drinking water is drawn from today. Pictured here is a typical area windmill that stood on the Brainard Estate. In 1965, four homes were built on this site, now known as the King's Path.

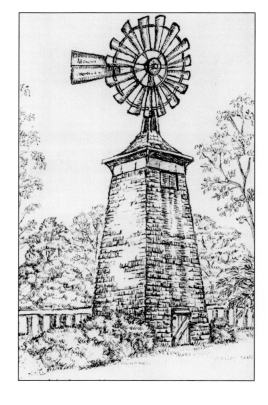

This sketch shows how the last remaining windmill in Brielle appeared when it was operational. Today this structure still stands at the foot of Ashley Avenue near Brown Street. While the structure has been partially renovated, the blades have long since been removed.

Two

Early Tourism in Brielle

In the early 1880s when the Brielle Land Association was selling vacation cottagès, the already prosperous hotel trade flourished as never before. This was no doubt greatly facilitated by the new Brielle railroad station. There were still very few permanent residents of the area, but the population swelled in the summer months with well-to-do families from the cities. They would spend the entire summer season in Union Landing either at a hotel or in a rental cottage or in their own summer home. The *Seaside*, a local paper in neighboring Manasquan, frequently published the goings on in Union Landing summer society in a gossip column of sorts. Activities enjoyed by these early tourists included swimming, sailboating, and picnicking on nearby Osborn Island, also known as Treasure Island. Robert Louis Stevenson christened it Treasure Island while vacationing here in May 1888 because it reminded him of the fictional island he created for his novel *Treasure Island*. Fishing had not yet gained the popularity it would enjoy here in the future. In later years, Union Landing became a center for the developing motorboating industry. Local sailboat-turned-motorboat builder S. Bartley Pearce was a pioneer in powerboat racing. In the early 20th century, Pearce brought the prestigious Harmsworth Racing trophy home to America after winning the 1907 International Cup Race in the *Dixie* on the English Channel. In 1908, he won the Harmsworth trophy again on the *Dixie II* in a race on Huntington Bay, Long Island, New York.

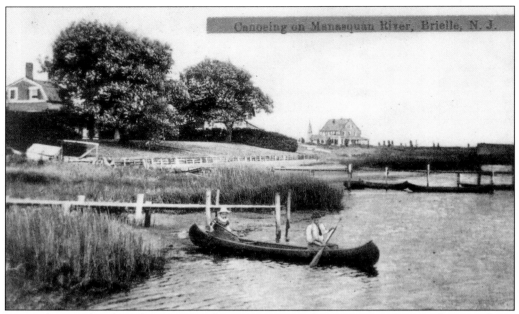

Many pleasant days have been spent riding in canoes on the Manasquan River. This area shows Crabtown Creek, which is the principal waterway that leads into the town of Manasquan from the Manasquan River. Manasquan was once known as Crabtown, after the crabbing industry that flourished there in the 1800s.

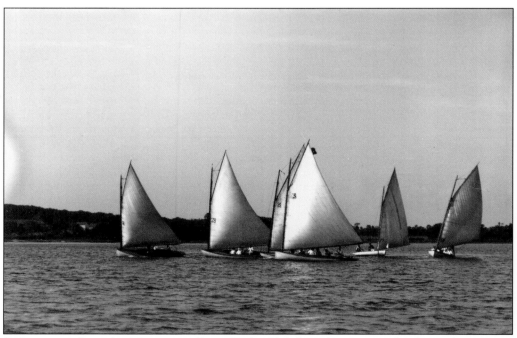

Sailing races from the Manasquan River Yacht Club have been a popular form of recreation and competition for over 100 years. Children of members are taught to sail at an early age. Construction of sleek racing sailboats was once a major industry here in Brielle.

This island was known as Osborn Island after the family who had owned it. On August 7, 1877, the *Seaside* newspaper reported one Jakey Herbert "has fitted up a fine saloon on Osborn's Island where he will be glad to get up oyster and clam bakes to order, and do all he can to make it pleasant for parties who may come there." A sloop in this photograph is bringing a party to spend some hours there. In May 1888, Robert Louis Stevenson and Will Low sailed up the river to Osborn Island and upon landing proclaimed it Treasure Island. To this day, many still refer to the island as Treasure Island.

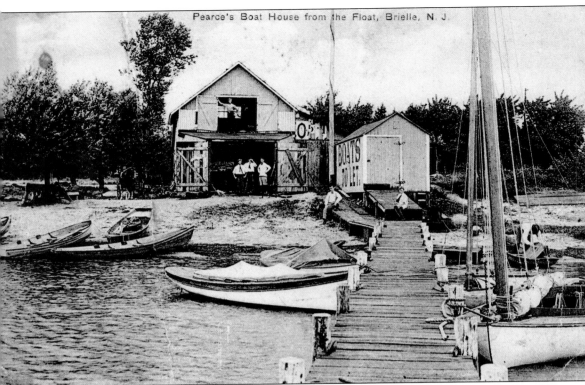

Pearce's Boat House from the Float, Brielle, N. J.

Capt. S. Bartley Pearce was one of the most prominent boatbuilders in Monmouth County. He built surfboats, pound boats, small sailboats, sneak boxes, and sloops. He was a charter member of the Manasquan River Yacht Club. In 1906, Pearce became interested in motorboat racing. He raced the motorboat *Dixie* in the famed Harmsworth Trophy Race. The trial runs were made on the Manasquan River with spectators lining the banks to watch. The *Dixie* won the race, and the trophy was brought to America in 1907.

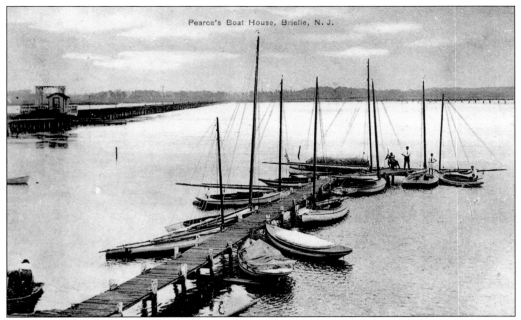

This c. 1905 view is of the Capt. S. Bartley Pearce boatyard and dock on the Manasquan River. This boatyard was located at 620 Green Avenue, which is now the Brielle Marine Basin. The New York and Long Branch Railroad swing bridge is shown on the left.

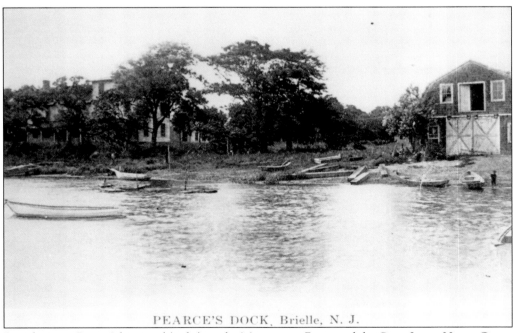

PEARCE'S DOCK, Brielle, N. J.

Seen here are Pearce's boatyard (right) on the Manasquan River and the Capt. James Henry Green homestead (left), which had been converted to a boardinghouse at the time of this photograph.

This c. 1914 photograph shows a pleasant day of boating on the Manasquan River, looking toward the Brielle shore with the Osborn Farm on the right. This site became the Manasquan River Golf and Country Club in 1922. In the distance are the Schroeder estate on the left and the Wing Estate on the right.

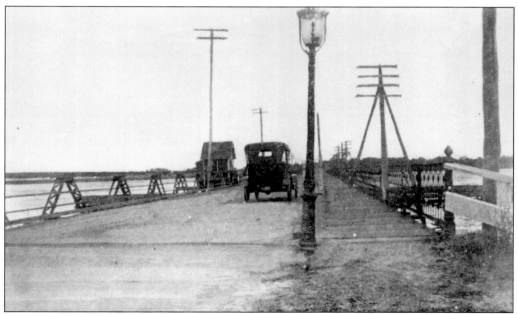

This picture of an automobile bridge over the Manasquan River looks south toward Point Pleasant Beach around 1910. The view was taken from Bridge Avenue, which was renamed Higgins Avenue in 1919. This is the site of the first New Jersey Route 35 bridge.

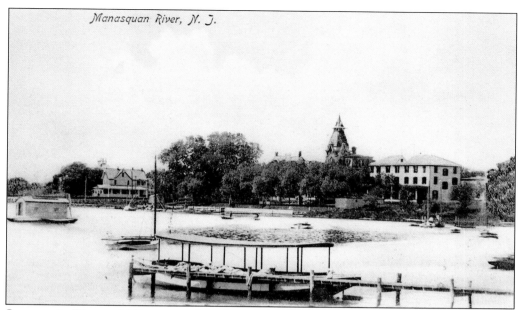

Sea captain Wynant V. Pearce purchased some land between the Union House and Scheibles's boardinghouse from Capt. John M. Brown. Pearce built the Crestdale House in the summer of 1877. It was constructed by builder James Spicer of Philadelphia as a private residence. Pearce, master of the *John A. Williams*, retired from the sea in 1887 and died on June 26, 1905.

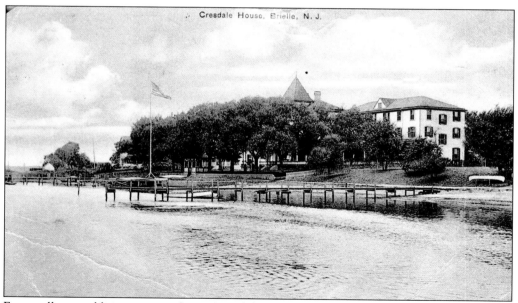

Eventually an addition was made to Crestdale and it became a rooming house for summer boarders. The plans were featured in an article in *Godey's Ladies Book*. This place was popular with the locals as well as summer guests because of the dances held there on Saturday nights. It burned during the summer of 1906. Shown at left is Scheibles's boardinghouse the Windemere.

JUNE 29, 1888.

CRESTDALE SCRIBBLINGS.

The "Jennie Arnold" is launched, and is hard to beat in the yacht line.

Mr. W. H. Wiley's family are cosily established at Osprey Bluff.

The storm of Wednesday night has swollen the streams and flooded the earth.

The intense heat of the past w :k has given place to a comfortable te - perature once more.

Mrs. C. V. Sanborn, the artist, is busy with her class amid the natural beauties of the section.

Little Miss Florence Hutchinson of Crestdale Villa, caught a mess of eels, her first lesson from Sir. Izaak Walton.

Mr. Bart Pearce, the boat architect, is now being assisted by Mr. John Pearce and Captain Louis Curtis, of Union Lane.

Gay equipages from the villages above and below may be seen daily bowling along the shore, taking in the beauties of land and sea.

Mr. George Butts is at the Union House. Messrs. Will Hart, Theo. Butts and Louis Benson, so well and favorably known along the shore, were down last Sunday.

The Season of '88 is fairly opened at the Carteret, and promises to be very successful. About fifty guests are due this week and applications are daily made for accommodations. In fact, at the present rate, an addition will have to be built to the hotel. Prof. Kramer, with his orchestra, so popular already among our citizens, will furnish music during the season, which will open with a grand hop on the 4th of July. A stage, free of charge will run to the seashore, and once a week the yacht, hired by the proprietor of the Carteret, will be at the service of his guests. The time is not far distant when the Carteret will rival all other seaside resorts. The register shows the following guests :— From Jersey City, Mr. and Mrs. E. Whyte, Mr. and Mrs. Jos. Bets, Miss Von Bamberger and Mrs. C. Schraedu and daughter. From Hoboken, Mr. and Mrs. Kemble, Mr. and Mrs. Feldstein and daughter, Mr. and Mrs. W. Lierck and family. From Brooklyn, Mr. and Mrs. Prentiss from New York, Mr. and Mrs. Perry.

Mrs. Richardson was the proud owner of a pig. Not a stuck pig, or a trained pig, or a roast pig. Just a live pig, whose comfortable proportions she had measured and calculated as to future usefulness in the culinary line. A pig with one ear slit and the other ear cropped, but with the usual complement of nose, eyes, feet, hide and tail. A spotted pig, in fact, of no mean pretentions. He was trusted in full with the limits of the grounds, and was educated to stop at home, quietly or squeakily, just as he pleased. Now, to show the value of early training where the spirit is restless and the morals are easy, his pigship helped himself to a hearty supper— very hearty—and then disappeared. Fled from his own vine and fig tree and swill trough to unknown seas. He was traced to the river bank where he took a boat for some strange port, whether foreign or native history sayeth not. But he was careful not to get muddy for, sad to tell, he purloined a pair of rubber boots and left plain tracks in the sand. He also had a sharp tussel with some other emigrating pig, (perhaps) for there were marks all about of a struggle. But Mrs Richards' pig, like Mrs. O' Leary's cow, came off triumphant and escaped. E.

"Crestdale Scribblings" was published weekly as a gossip column in the Manasquan newspaper the *Seaside*. News of parties, weddings, births, and other auspicious news kept summer tourists and locals alike informed of the area's goings on. The *Seaside* later became the *Coast Star* and is still published today.

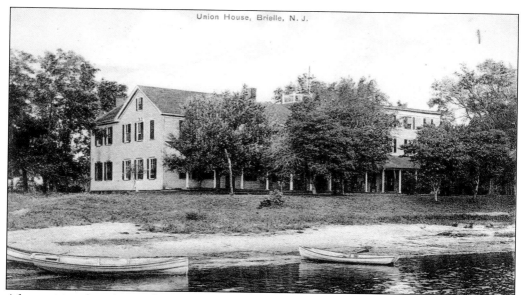

Union House, Brielle, N. J.

After retiring from his seafaring in about 1860, Capt. John Maxon Brown opened his family homestead as the Union House. The Union House was one of the earliest hotels on the banks of the Manasquan River. Robert Louis Stevenson stayed here the month of May 1888 in an attempt to regain his health. While here, Stevenson wrote a portion of *The Master of Ballantrae*, learned the art of sailing a catboat, and gave a famous name to an island in the middle of the river. An early-morning fire on February 15, 1914, totally destroyed the hotel.

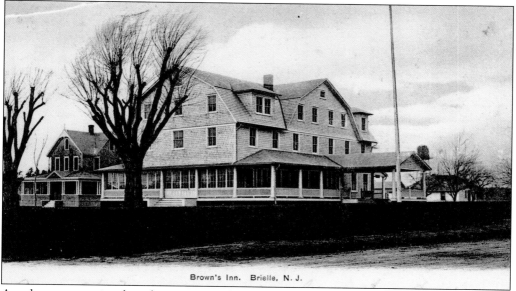

Brown's Inn. Brielle, N. J.

Another sea captain whose home was on the Manasquan River was Theodore S. P. Brown, one of seven children of Capt. John Maxon Brown, who had established the Union House. Theodore sailed the schooner *Charley Woolsey* a number of times as far as Charleston, South Carolina. Retiring from the sea, he took up the "hospitality calling" and opened Brown's Inn near his homestead on the river. Brown's Inn was located on the riverfront near the end of Brown Street next to where Bogan's Basin is now located.

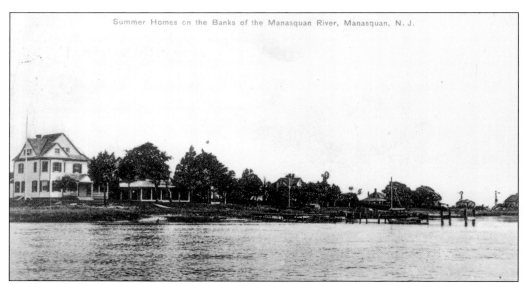

Private homes, cottages, and villas dotted the Manasquan River shoreline during the late 19th and early 20th century. The *Seaside* newspaper frequently reported the attractions of this lovely part of the river stating, "Here is yachting and fishing and crabbing to the heart's content. Here may be seen anytime, guests of the different houses rowing and catching crabs and having a good time generally. The river affords an opportunity for people to go out where they please, stay as long as they please and be the captains of their own crafts, on a broad body of water feeling all the time that you are perfectly secure."

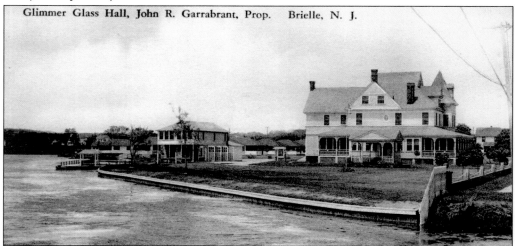

Glimmer Glass Hall, John R. Garrabrant, Prop. Brielle, N. J.

Built in 1885 by a Mr. Behringer of New York City as a summer home, Glimmer Glass Hall was located on the Glimmer Glass, which is an arm of the Manasquan River. This summer hotel faced Park Avenue and was a short walk from the New York and Long Branch Railroad Station, an important consideration in the late 19th and early 20th century. In addition to ocean bathing, which was only a short walk away, prime vacation activities were boating and fishing on the river. The Glimmer Glass itself was rather shallow at low tide. The building was at various times the Hotel Castlewood and Dodd's Brielle. A fire destroyed the top floors in the 1950s, but the remainder was saved and became Bar Casablanca. This is now the site of Drawbridge West condominiums.

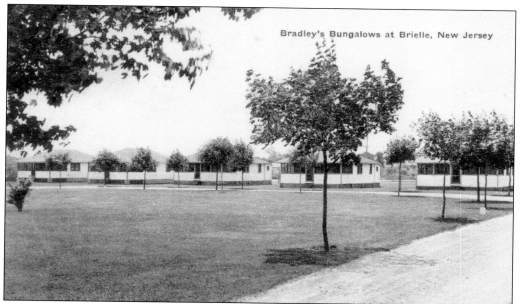

Bradley's Bungalows at Brielle, New Jersey

To the west of Glimmer Glass Hall was a bungalow colony owned and operated by Chester Bradley, who rented to summer guests. The driveway in front of the bungalows pictured is known today as East Woodland Avenue. Most of the bungalows were razed and replaced by larger homes, but a few were converted to year-round residences and remain today.

The Brielle Land Association had erected a fine new Queen Anne–style hotel at its development. This establishment was named the Carteret Hotel. After changing owners and becoming the Brielle and the Baxter, the building went up for sale and was purchased in 1895 by D. Gerlach, who established a boys' military school named Gerlach Academy. The charge for board, room, and tuition was $500 per year. This institution remained in existence for about 20 years.

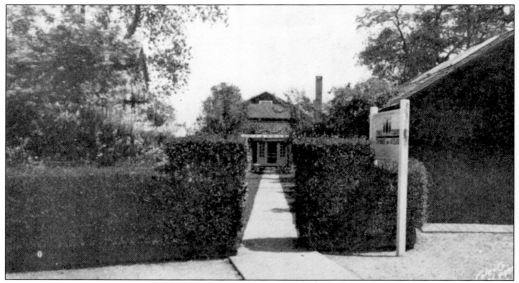

About 1910, Catherine Freeman, wife of well-known impressionist painter Charles H. Freeman, opened the Three Cedars Tea House at their riverfront home at 504 Green Avenue. Afternoon tea and desserts were served on the lawn facing the river in nice weather or on the glassed-in porch on rainy and cool days. Charles's studio was on the property by the street. This place became very popular, and many famous people visited there, including silent-screen actress Mary Pickford. In later years, Fred Astaire and his sister Adele, writer Albert Payson Terhune, and radio commentator Lowell Thomas also visited. Both buildings still stand today.

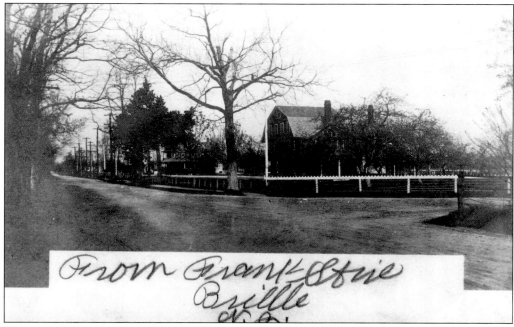

This postcard was written to a Mrs. Gildersleeve in Brooklyn by Frank Stires on February 24, 1908. The image shows Union Lane looking west at the intersection of Green Avenue. The homes pictured still stand today.

The house Greystone pictured here was the summer residence of Frank Ward O'Malley, a well-known author and newspaperman of the *New York Sun*. This house still stands today on the east side of Schoolhouse Road. When it was built, the house had panoramic views of the Atlantic Ocean and the surrounding farmlands. The house was sold in the 1920s to Darcy Scudder, who was an architect and commuted to New York City.

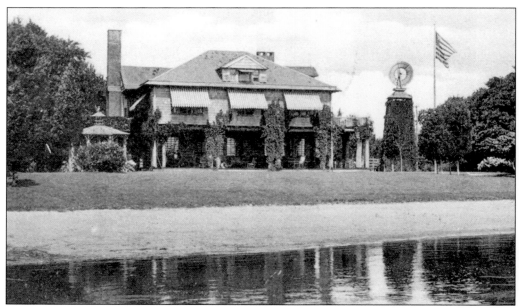

This c. 1880 photograph is of the house named Tippecanoe-on-Manasquan, built originally as a hunting and fishing lodge. Prior to his election as the ninth president of the United States, William Henry Harrison visited here. His nickname was Tippecanoe after his victory at the Battle of Tippecanoe in 1811. The proprietor of the lodge changed its name to Tippecanoe Farm. George H. Risley, one of the early owners of the property, instructed workmen to construct a swimming pool in the river that would change its water with the tide twice each day. Note the ubiquitous windmill to the right of the house. In the 1920s, this house was moved away from the riverbank to the corner of Riverview Drive and Isham Circle where it still stands.

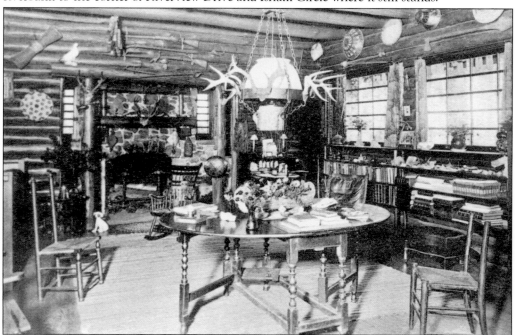

Three

THE BOROUGH
OF BRIELLE,
INCORPORATED 1919

On June 9, 1919, the newly incorporated Borough of Brielle held its first council meeting in the upstairs room of the Brielle Fire Company headquarters. The exact reason for secession from Wall Township is unknown, although it is known that it was an extensive process requiring a general referendum question on the ballot during the June 1919 primary election. Some speculate that the reason was related to a desire for home rule of the local school. At the time, schools were built and operated by Wall Township. The prior year, a brand-new school had just been constructed by the Wall Township Board of Education on the corner of Union Avenue and Union Lane. Early council minutes relate in great detail the settling of financial accounts with Wall Township and the establishment of basic municipal services for the residents of Brielle including creating the police department, street department, and water department. The single exception is the Brielle Fire Company, which had existed since 1910 when it was established as the Brielle Chemical Company, a part of the Wall Township Fire Department. It is interesting to note the very first action of the mayor and council was to commemorate the young men of the new borough who served their country during World War I.

June 9, 1919.

The Mayor and Council of the Borough of Brielle met at 8 P.M. on the above date in the meeting room of the Brielle Fire House. Those present were Mayor Richard A. Donnelly, Councilmen John H. Folk, Wilbur Allen, James Brewer, Edmund L Edwards, Theodore J.R. Brown and John W. Bennett.

The following resolution was introduced by Councilman Brown who moved its adoption:-

Whereas, the formation of the Borough of Brielle marks the end of the World's War; and

Whereas, it is deemed most fitting and appropriate as the first official of this Mayor and Council to permanently commemorate the patriotism of the young men who served their Country;

Now therefore, be it resolved that the names and military records of each and every young man of this Borough who served in the Army and navy forces of the United States in the said World War be inscribed upon and made a part of the minutes of this this Organization's meeting.

And be it further resolved that a copy of this resolution properly inscribed be given to each of the said young men or their heirs as a small token of the thanks and appreciation of the people of the Borough of Brielle for their patriotic and faithful devotion to duty in the service of their country.

Mr. Brown's motion for adoption was seconded by Councilman Allen and all present voted unanimously in the affirmative.

Mayor Donnelly appointed Harry H. Kroh to be borough clerk. On motion of Mr. Folk, duly seconded, the nomination was unanimously approved. The oath of office was administered to Mr. Kroh.

On motion of Mr. Brown, seconded by Mr. Allen and carried it was decided that all items which have been contracted for or which may become a charge against the borough through the organization of the municipality be presented to council on or before the next meeting.

A motion by Mr. Brown setting Monday night of each week as the time of meeting for council was seconded by Mr. Brewer and unanimously adopted.

Mayor Donnelly announced the following committee appointments, which, upon motion by Mr. Brown, seconded by Mr. Allen, were unanimously confirmed:-

Finance:- Messrs Folk, Brown and Bennett.
Lights:-Messrs. Brwer, Allen and Edwards.
Streets:-Messrs. Bennett, Allen and Brewer.
Law & Ordinance:-Messrs. Brown, Folk and Brewer.
Printing:- Messrs. Folk, Edwards and Brewer.
Poor:- Messrs. Edwards, Brown and Allen.
Fire:- Messrs. Allen, Bennett and Brewer.

It was moved by Mr. Brown, seconded by Mr. Allen and carried that the clerk be authorized to secure the necessary minute books.

These minutes are from June 9, 1919, the inaugural meeting of the mayor and council of the newly incorporated Borough of Brielle. The first resolution introduced and adopted commemorated the service of World War I veterans of the newly established borough. Further acts of the council that night established committees and began the process of settling financial accounts after Brielle's separation from Wall Township. At the next meeting, the mayor and council renamed the east side of Park Avenue to Fisk Avenue and Brielle Avenue to Higgins Avenue. Higgins and Fisk were two residents killed in action during World War I.

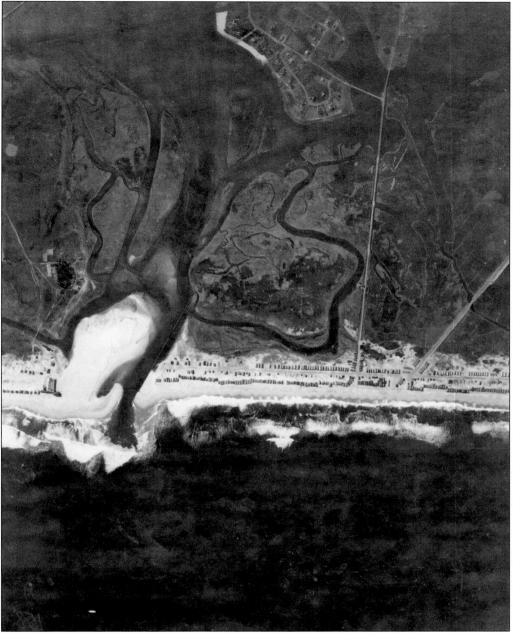

This 1920s aerial photograph is from a survey made by the U.S. Army Corps of Engineers. The subject of the study was beach erosion along the New Jersey coastline. This picture shows largely undeveloped Brielle, as well as the Manasquan River and Inlet as it appeared prior to the construction of the Point Pleasant Canal.

This post office in the Brielle area was established in 1888 in a small corner of a general store owned and operated by Henry Wainwright in conjunction with the historic Union House. Wainwright was appointed postmaster. Clarence Marsh, the first postal worker, was also on duty. The first telephone in Brielle was located in the post office. When Wainwright died in 1911, his son Stanley took over as postmaster. This building was located on the river end of Union Lane. There were 78 postal boxes. Mails closed at 6:40 a.m. and 10:10 a.m. and at 3:35 p.m. in order to be caught by appropriate trains. The post office was destroyed when the Union House burned down in February 1914.

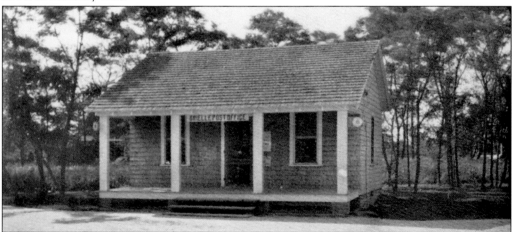

After the Union House burned, this post office was constructed in 1914. This building was the first structure in Brielle actually built to be used as a post office. Henry Kroh served as postmaster in this building. Kroh was succeeded as postmaster by his daughter Annanette Kroh. This public building was built without a bathroom, and when necessary, Annanette would need to close the post office to use the facility at her home next door. Mail arrived when the train from New York would throw a mailbag off while traveling by. Outgoing mail was placed on an arm and trains would pick it up on the return to New York. Despite several renovations, including adding a bathroom, putting in heat, and actually elevating the building, the exterior of this little building still looks much the same today. In 1956, a new post office was constructed at its current location on Higgins Avenue.

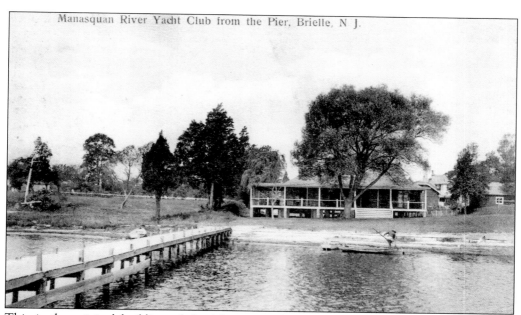

Manasquan River Yacht Club from the Pier, Brielle, N. J.

This is the original building of the Manasquan River Yacht Club, which was founded on September 13, 1899, by a group of interested citizens. The building pictured here was the club's second home. It was previously the Wiley Estate that the club purchased in 1905 and is pictured here about 1915. Organizational meetings were held in the home of J. H. Folk, a summer resident from New York.

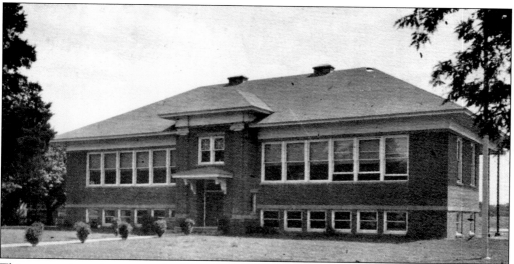

This was an ingenious way to build a school with future expansion in mind! The front half of the school was constructed in 1918, and it was completed with the back half being added in 1928. The roof of the entire building was part of the original construction. The roof was held up with cast-iron poles, as is seen in this photograph. The first four classrooms included two in the basement and two upstairs for the whole school, which included grades 1 through 8. There were two class grades in each room with one teacher providing instruction for both grades. As the school population grew, the back half was added. This building is used currently as Brielle Borough Hall and is located at the corner of Union Lane and Route 71 (Union Avenue).

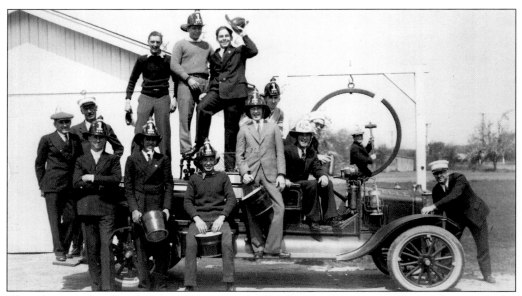

This photograph taken in May 1931 shows the Brielle Fire Company posing with an early fire engine. The man starting the engine is Granden J. Pearce, and the man ringing the fire alarm is George W. Legg, who later became Brielle's first paid chief of police. Other men identified include Harley L. Voorhees, Arthur Pettit, Harry Molley, John Rogers, Magnus Nielson, Bowditch Pearce, Harry Morton, Edward Stires, Wilbur Moore, George Buckley, Vernon Briggman, and Willard Van Sickle.

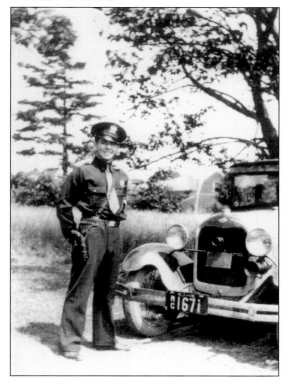

John Rogers, one of Brielle's first police officers, stands by an early Ford Model A automobile. This was the first car purchased by the town to be used specifically as a police car. Mayor Allan L. Powell on March 11, 1929, vetoed the resolution accepted at a council meeting to purchase a Plymouth automobile for $600 because the Ford could be had for $591 fully equipped, including chains and lettering, whereas the Plymouth car came without extra equipment.

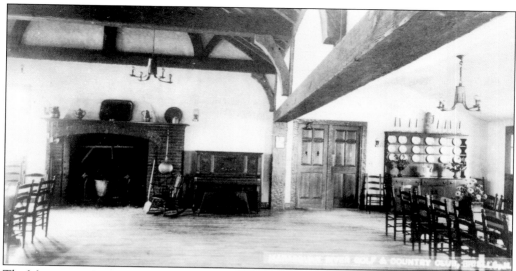

The Manasquan River Golf and Country Club was established in 1922 and purchased the Charles Osborn farm. The brick farmhouse was remodeled into the original clubhouse. The large room pictured above was added to the original structure and was modeled after the American Room at the Museum of Natural History in New York. The front porch of the Osborn farmhouse was enclosed after the club purchased the property to accommodate additional clubhouse space. After the stock market crash of 1929, the club was almost bankrupt. A syndicate formed by Lee Bristol of the Bristol Meyers Company and other well-to-do members lent the club money to satisfy its debts. Reorganized as the Manasquan River Golf Club in 1935, it is a popular and well-known course. Major golf tournaments are held here.

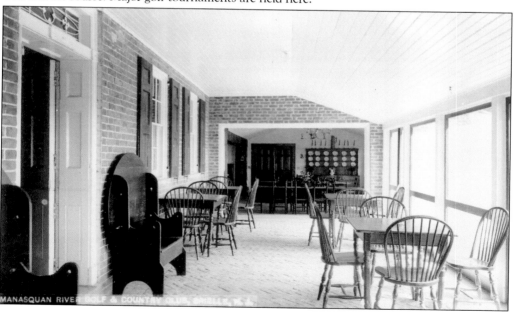

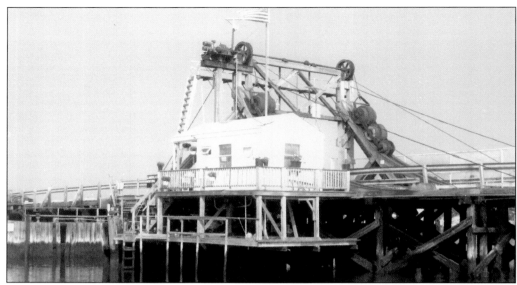

A bascule drawbridge design like this was a popular style of bridge at the end of the 19th century. This bridge was designed and originally constructed at another location. It was moved to this location connecting Fisk Avenue in Brielle to Brielle Road in Manasquan in 1937. The bridge was dedicated on August 13, 1938. This unique structure, which is being considered for the National Register of Historic Places, provides access to the north end of Manasquan Beach from Brielle. As far as is known, this is the last bascule drawbridge of its type still functioning in the United States of America.

The Folk Agency Realtors is located at the corner of Riverview Drive and Higgins Avenue. It was established in 1920 by Howard Folk and is the oldest continuously operating business in Brielle. Built in 1934, the building pictured here remains unchanged today.

Four

OPENING MANASQUAN INLET AND THE SPORTFISHING INDUSTRY

In 1925, the construction of the Point Pleasant Canal connected the Manasquan River to the uppermost point of Barnegat Bay, and a key section of the Atlantic Intracoastal Waterway to Florida was completed. An unwanted side effect of the project was the complete closure of the Manasquan Inlet to the Atlantic Ocean. The river's natural outward flow into the ocean took the easier path through the canal and emptied into the bay. The inlet drifted position and sometimes closed up over the centuries, but never as completely as it was then. This brought a virtual halt to maritime commerce, crippling the local economy. The U.S. Army Corps of Engineers began a project to create a permanent inlet opening, funded by federal, state, and local tax dollars. The project was complete in August 1931, and the permanently reopened inlet allowed shipping and fishing activities to resume. Reopening the inlet, the development of powerboats, the growing popularity of the automobile, and Brielle's sheltered riverfront combined to make it the ideal spot for the new sportfishing industry to flourish. Over the next few years, a fleet of private fishing vessels and large party boats amassed at the docks of Brielle. Anglers flocked to Brielle from all over the world to compete in world-renowned tournaments or simply enjoy a day of fishing.

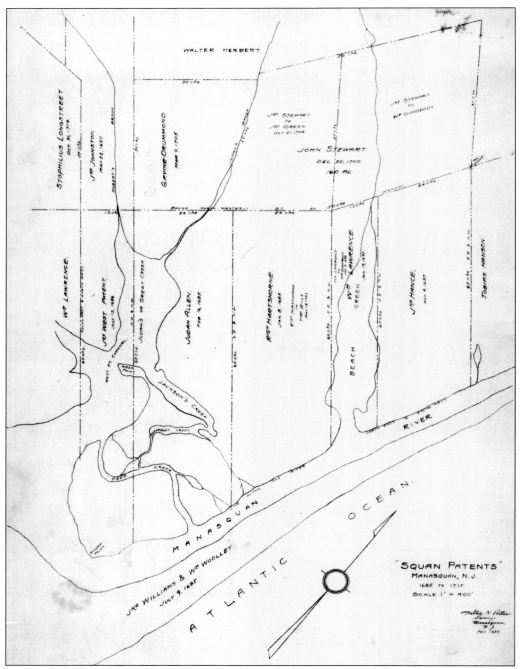

This map of the mouth of the Manasquan River was originally drafted in the early 18th century. The overall appearance of the mouth changed over the centuries, the currents and storms moved sandbars and shoals frequently. Note the opening to the ocean is considerably farther north than it is today, very close to the present Manasquan and Sea Girt border. This location is where the first life saving station was constructed in 1856. In 1915, the U.S. Life-Saving Service was combined with the U.S. Revenue Cutter Service to form the United States Coast Guard.

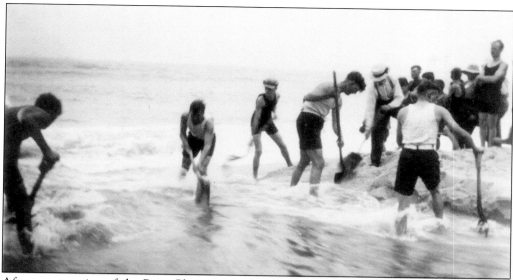

After construction of the Point Pleasant canal in 1925 to connect the Manasquan River with the northern end of Barnegat Bay, the prevailing currents changed drastically. Water flowed from the river south into the canal, emptying into Barnegat Bay rather than flushing out the inlet at the ocean. This change caused the entire inlet mouth to become totally blocked by sand and no longer navigable. Efforts to clear the inlet mouth by manual excavation like those shown here in 1926 were moderately successful for only a short time. The prevailing currents always closed the inlet again.

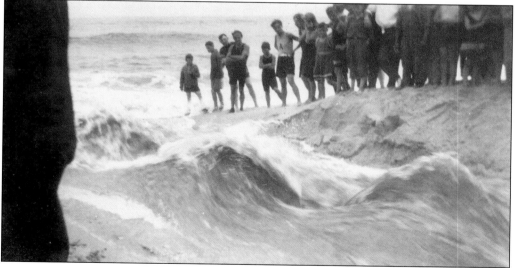

With the inlet blocked by sand, all maritime commerce into and out of the Manasquan River area came to a standstill. In cooperation with and with the financial backing of federal and state agencies, the four towns of Brielle, Manasquan, Point Pleasant, and Point Pleasant Beach each pledged $25,000 to the cost of constructing a permanent river opening to the ocean. Pledges were first made in 1929, but by the completion of the project in 1931, each borough was hard pressed to make payment due to the Great Depression.

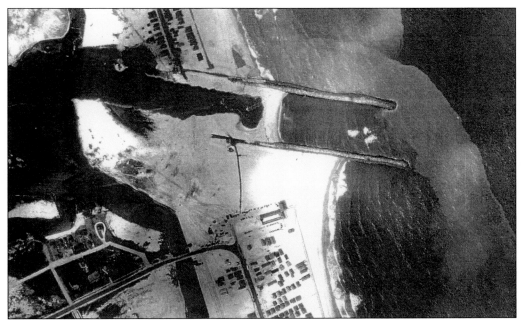

The first step of the project was the construction of parallel stone jetties into the ocean at the planned location of the inlet mouth. The large stones used to build these jetties were excavated from the Sixth Avenue IND Subway line construction in New York City. Once the jetties were completed, the work of clearing out the passage was begun. This aerial view of the inlet shows the extent of the area that had to be excavated. Steam shovels were used to remove the sand, and the spoils were transported to a man-made island in the river close to the Brielle shoreline ultimately known as Sedge Island.

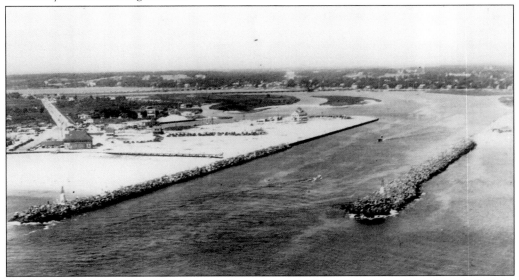

Once the inlet was permanently reopened, maritime traffic resumed, much to the relief of the many local businesses that came to rely on ocean access from the river. Since 1931, the inlet has not closed up due to silting, but it still must be dredged periodically to insure an adequate depth is maintained.

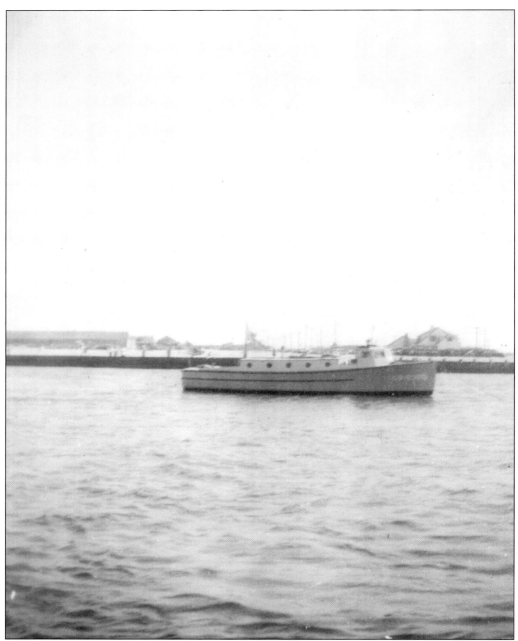

A Coast Guard cutter is shown here en route through the Manasquan Inlet. In 1936, the Coast Guard built a new station in Point Pleasant Beach on the south side of the inlet. This new station was required since permanent ocean access was established at the present location. The old 1856 Manasquan Coast Guard station once stood in close proximity to the old, nonpermanent inlet opening. That station was not decommissioned, for it housed an electronics shop and a large radio tower. The shop is now closed, and the building was sold to the Borough of Manasquan for $1. The building will be restored to its original appearance for use as municipal offices and a community center.

Windemere was the name of the large boardinghouse owned and run by the Andrew Scheible family. This house was on the riverfront where Bogan's Basin is now located. When the Route 35 bridge was rebuilt and the roadway realigned in 1949, the house was moved a few hundred feet and now faces Ashley Avenue. Scheible ran a stage from the various hotels in the area and transported the patrons to the ocean beach. Scheible's dock was later purchased by John Bogan and became the site of Bogan's Basin. It was on the front porch of this building in September 1934 that bodies from the *Morro Castle* disaster were placed pending identification.

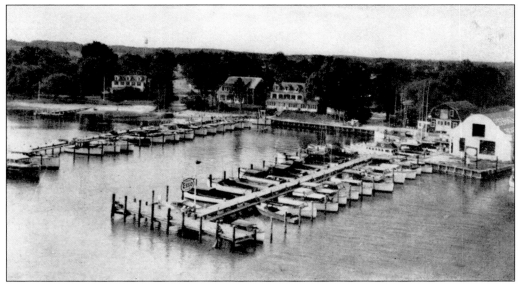

Charter and private boats at the marina rest quietly on a glassy river. From left to right in the background are Henry Hessler's home, Capt. Sam Good's place, and the James H. Green homestead. Also in the background is S. Bartley Pearce's boathouse flanked by the larger Feuerbach and Hansen building. Between Good and Hessler's house, Union Lane ran westward past the Brielle water tower to Paynters Road.

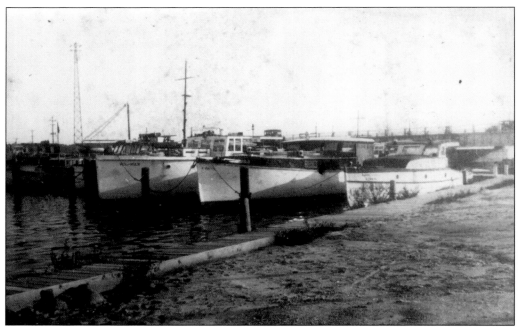

This is a 1934 view of the Manasquan River Yacht Basin adjacent to the second Route 35 automobile bridge over the Manasquan River. A section of this bridge would later collapse in 1946. It was hastily repaired, and plans were drawn to replace the span with the present bridge.

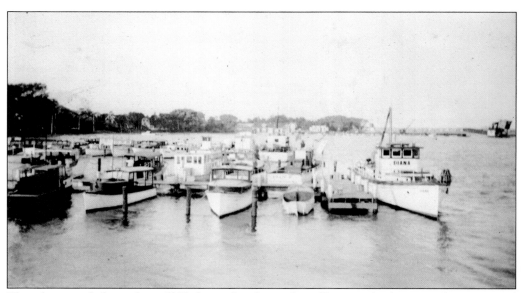

This photograph from about 1935 shows the charter boat *Diana* and other party boats moored at Manasquan River Yacht Basin. The railroad drawbridge span is in the background. The *Diana* was built in 1931 and was owned and operated by Capt. Robert Ziegler. The U.S. Navy requisitioned her during World War II as a coastal patrol boat. After the war, the navy returned the vessel to Ziegler, who operated it until 1974 when it was sold.

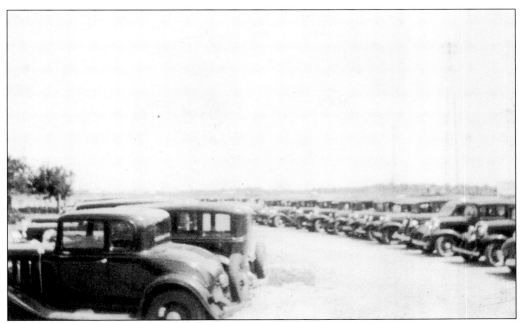

July 30, 1935, was a very busy day for Manasquan River charter boat captains, as is evidenced by the packed parking lot at the corner of Ashley and Higgins Avenues. Many of these cars no doubt traveled a good distance to Brielle, and there were no major highways yet and the Garden State Parkway was still some 20 years in the future.

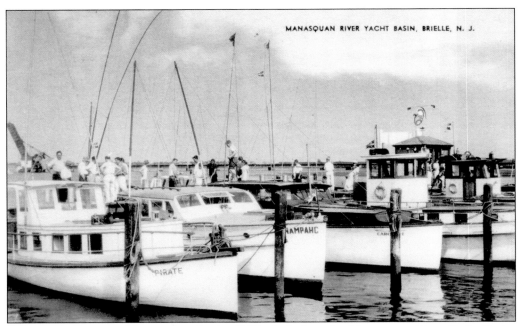

Here is a look at the Chappy fleet in the 1930s docked at the Manasquan River Yacht Basin. Note the name of one of the vessels, *Nampahc*, is Chapman spelled backwards, it was one of Capt. George Chapman Sr.'s fleet.

The schooner *Caroline* from Providence, Rhode Island, anchored overnight prior to venturing down the Intracoastal Waterway. The Atlantic Intracoastal Waterway was established by an act of Congress in 1919 and provided a largely inland water route between Maine and Key West, Florida. Mariners followed a near coastal route from Maine to the Manasquan Inlet where the inland portion of the waterway began. With its proximity to the unofficial beginning of the Atlantic Intracoastal Waterway, Brielle became an important stopping point on the route to Florida.

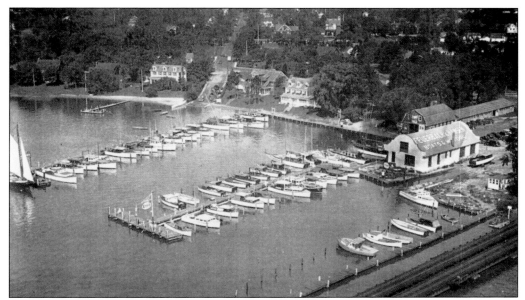

Pictured is the heart of the charter fishing boat fleet at Feuerbach and Hansen's around 1938. The road leading down to the riverfront was once the site of a long wharf known as Union Landing. Union Landing was a major center for the coasting trade, which was the primary means of transporting goods up and down the East Coast by water. The Union Salt Works was located here and operated during the Revolutionary War. It was burned by the British in April 1778. The Union Salt Works was quickly reestablished as it was the leading supplier of salt for Washington's army since the British had embargoed imported salt from the Caribbean islands.

The headboats *Dolphin*, *Albatross*, *Paramount*, and *Diana* are loading up for a day of deep-sea fishing in the Atlantic Ocean, leaving from the Manasquan River Yacht Basin. The *Albatross* was a skipjack boat built in 1936 by Ernest Fiedler in Brooklyn, New York. It was owned by Capt. Henry Hillman and operated by Capt. Dick Wilson.

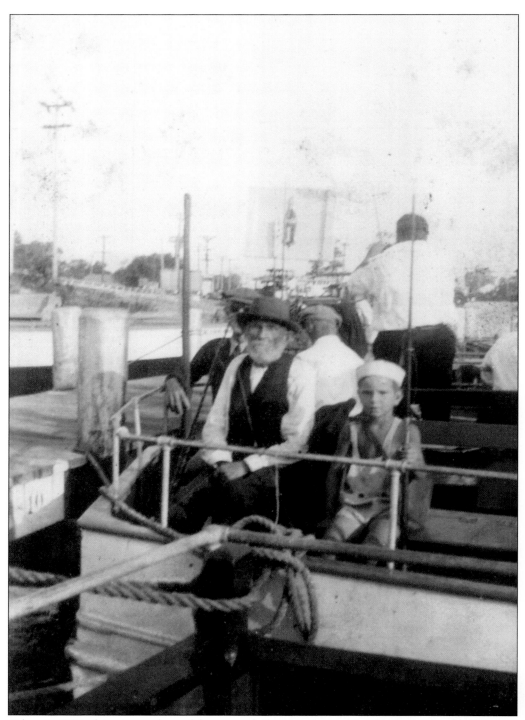

Taken in 1934, this picture shows fishermen of all generations patiently waiting for the 8:00 a.m. sailing time of one of the bottom boats with high hopes of catching a bag full of fish. The source identifies the old man as 92 years of age and the young boy as 7 years of age.

The Bogan family came to Brielle in the early 1930s from Brooklyn, New York. Capt. James "Speedy Jim" Bogan Sr. founded a fishing dynasty here that continues today. This picture predates the establishment of the landmark Bogan's Basin deep-sea fishing fleet.

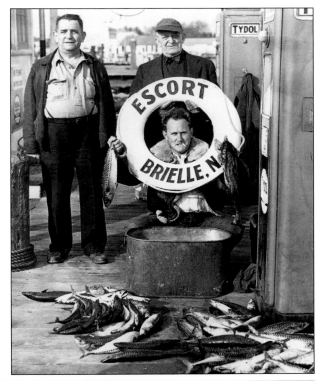

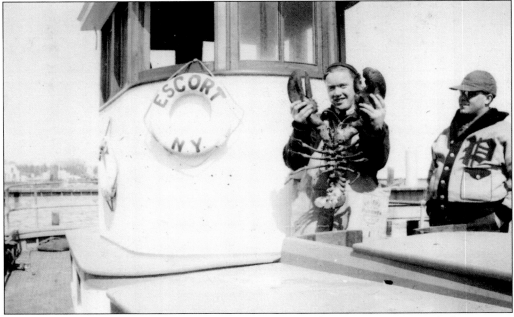

Fish are not the only game in this part of the Atlantic. This creature, commonly known as a Maine lobster, is more correctly called the American lobster and is found along the East Coast from Maine to the Carolinas. Occasionally a lobster would get tangled in an angler's line and be brought to the surface.

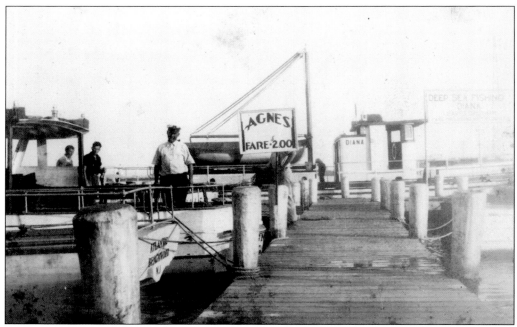

Captain and crew of the head boat *Agnes* stand ready at the dock, awaiting passengers who in the 1930s paid a $2 fare for half day of deep-sea fishing in the Atlantic.

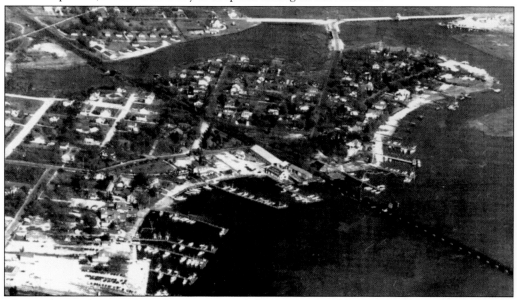

This early aerial view of Brielle's commercial docks includes the Anchorage, the Brielle Yacht Club, Hoffman's, Feuerbach and Hansen's, Sam Good's Place, Hessler's, Zuber's, Brielle Inn, and Bogan's. The three bridges over the Glimmer Glass connect Fisk Avenue, Brielle Road, and Green Avenue. The railroad bridge is pictured also. The waterway in the top center in the three bridges area is now largely filled in. The Fisk Avenue bridge on the left arm of the T has been filled in and replaced with a culvert. The historic Glimmer Glass drawbridge can be seen on the right arm of the T.

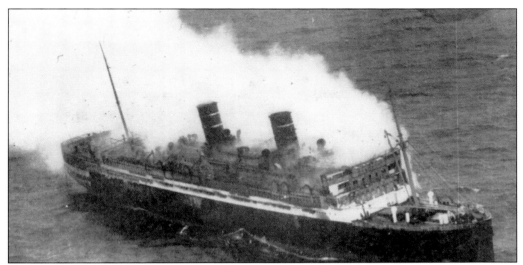

On the night of September 8, 1934, the Ward Line luxury liner *Morro Castle* was returning to New York traveling past the Manasquan Inlet when a fire broke out below decks. Capt. John Bogan Sr. of Brielle was one of the first rescuers on the scene with his fishing boat the *Paramount*. Bogan and crew tirelessly ferried many survivors to shore that night. Despite the rescuers' valiant efforts, 137 passengers and crew perished in the accident. A design flaw in the life jackets of the day caused many passengers to unwittingly leap to their deaths from the upper decks. The configuration of the life jacket, combined with the force of hitting the water, caused their heads to snap backwards, breaking their necks. The Coast Guard instituted many new standards for passenger safety following this tragedy. This view shows the vessel still afloat and ablaze. The exact cause of the fire has never been determined.

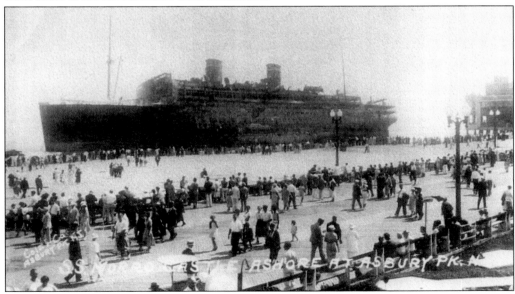

By the time the flames on the *Morro Castle* had extinguished themselves, the hull had drifted northward and ran aground at Asbury Park. It remained there as a tourist attraction for a time. Eventually it was towed away and sold for scrap. Survivors and casualties from the disaster were brought to various hotels and private homes throughout the area.

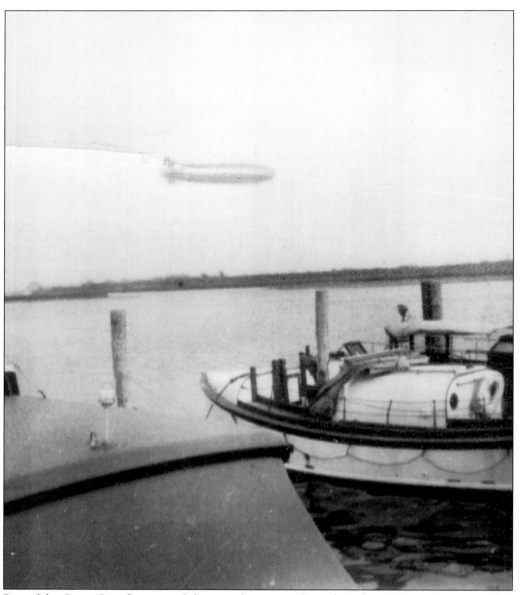

Part of the Coast Guard's responsibility was the rescue of vessels in distress in rough waters. This Coast Guard double-ender would right itself if it capsized. Note the German zeppelin *Hindenburg* in the background.

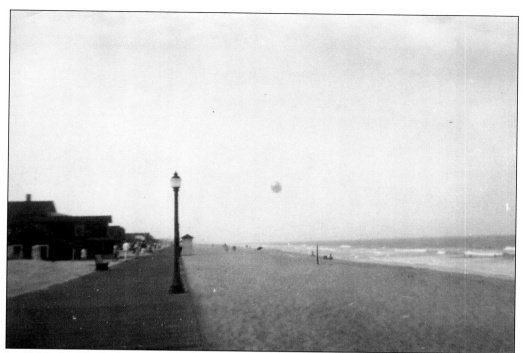

In 1936, the *Hindenburg* is shown approaching 393 Beachfront in Manasquan on its way to Naval Air Station Lakehurst. In addition to the bow lettering *Hindenburg*, the Olympic rings can be seen amidships on the airship, as Germany was the host country of the 1936 Olympic Games. The *Hindenburg* made regular passenger runs from Europe past New York City and the Jersey shore until it burst into flames while mooring at Lakehurst on May 6, 1937.

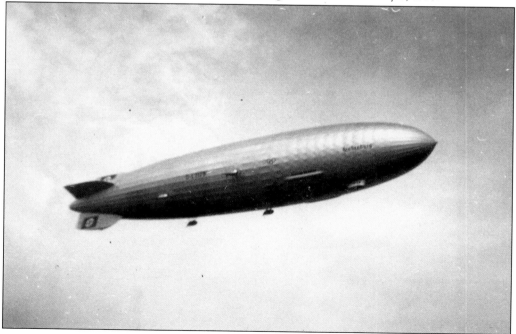

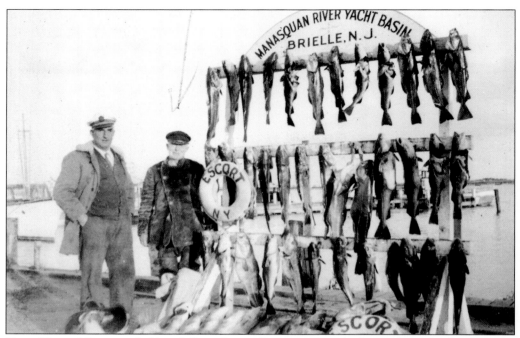

Capt. Howard Duncan (left) and Capt. Jimmy Bogan pose with the catch of the day from the *Escort*. The 46-foot *Escort* was built in 1936 in Brooklyn, New York. The life ring still indicated New York as the *Escort*'s home port, not Brielle.

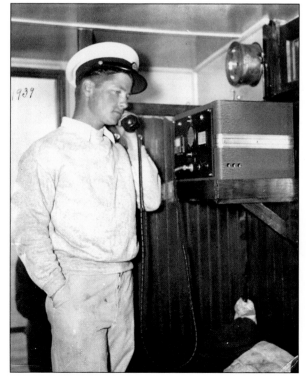

This picture shows Capt. Robert Ziegler on board the *Diana* using his new radio. The shortwave radio was a recently added luxury and safety feature for charter boats. Before their popularity, carrier pigeons were still used to send messages between vessels and the land. Boat captains would rent pigeons before departing and release them with messages to update those shore side or as a distress signal.

MANASQUAN RIVER
MARLIN AND TUNA CLUB

TELEPHONE
Manasquan 3191

HOFFMAN'S ANCHORAGE
BRIELLE, NEW JERSEY

OFFICERS

FRANCIS H. LOW, *President*
ORTON G. DALE, JR., *Vice-President*
LEO B. TRAVERS, *Treasurer*
JOHN MURRAY, *Secretary*

CLUB CHARTER BOATS

Captain	*Boat*
Geo. Burlew	"Gloria II"
Alonzo Carver	"Bessie C"
Harold Driscoll	"Stroller"
Kenny Foster	"Fun"
Clarence Hall	"Louise D"
Bob Hampton	"Aubrey"
L. Huntington	"Drone III"
Jesse Hyden	"Hy-Ball"
Lou Lyne	"Hulda"
Warren Mason	"Southwynd"
F. L. McBride	"Black Hawk"
Paul Mitchell	"Lark"
Edwin Patterson	"Smuggler"
Ed. Snyder	"Ma-Fren"
Thompson	"Miss Hannah"
Clifford Todd	"Margan"
Chas. Van Note	"Mi-Own"
Jos. Weiss	"Bidou"
Jack Weygant	"Amigo"

Reservations of these boats may be made by
telephoning the Club.

Overnight accommodations, breakfast and box
lunches are available at the Club House.

Applications for membership may be obtained
at the Club House or from the Secretary.

MANASQUAN RIVER
MARLIN AND TUNA CLUB

Second Annual
Fishing Derby

May 1 to November 1, 1937

Featuring

Manasquan Tuna Trophy

PRESENTED BY

Mr. FRANCIS H. LOW

TELEPHONE
Manasquan 3191

HOFFMAN'S ANCHORAGE
BRIELLE, NEW JERSEY

In a typical event of the day, the Manasquan River Marlin and Tuna Club sponsored a yearlong fishing derby in 1937. Various prizes and trophies were awarded. This pamphlet lists the club charter vessels available for use during the tournament along with the club's officers that year. The reverse side (not shown) also lists private vessels of members and the categories of competition in the tournament.

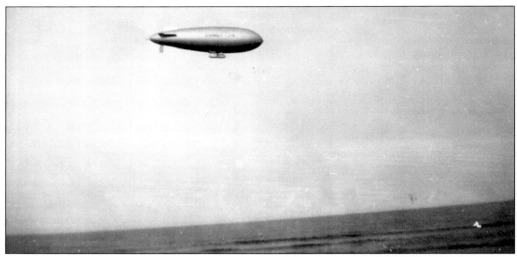

The U.S. Navy blimp J-4 based at Naval Air Station Lakehurst patrols the waters offshore. The J-class blimps measured 196 feet in length and had a maximum speed of 60 miles per hour. Four were built by the U.S. Navy between 1922 and 1933. The navy experimented with lighter-then-air ships in the early 20th century, and many were based in nearby Lakehurst. Following the loss of the dirigible USS *Akron* in 1933 and the *Hindenburg* disaster in 1937, the military and commercial uses of dirigibles and blimps waned.

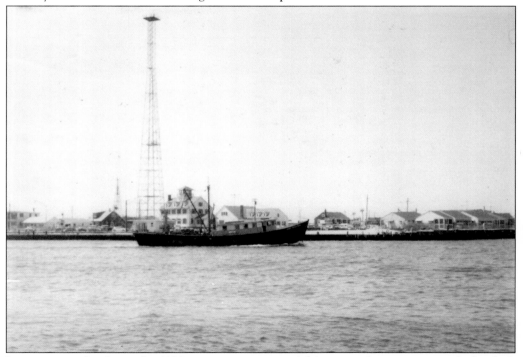

It was a typical sight in the 1930s to see a commercial fishing trawler returning with the day's catch. Since the opening of the inlet in August 1931, this area had become a very popular regional sportfishing center as well as home to commercial fishing boats. Also visible is the new 1936 Coast Guard Station in Point Pleasant Beach.

Five

BIG-GAME FISHING

Throughout the 1920s and 1930s, changes were taking place in the sportfishing industry. For centuries, men used nets to scoop up large quantities of small fish. This was fine if one were fishing for food, but at the beginning of the 20th century, a new kind of fishing emerged—sportfishing. Armed with a baited hook and line, a rod for leverage, and a reel to wind up the line, sportsmen began to compete to see who could catch the biggest fish. Advances in materials and design of tackle enabled anglers to pursue bigger and bigger fish. Giant tuna and billfish were the new quarry for the new breed of angler, the big-game fisherman. Although the sport was largely dominated by men, there were a fair number of women involved in big-game fishing. The mechanical advantage given by the tackle enabled women to easily compete alongside men for the same size fish. Brielle resident Eugenie Marron was one of the most famous female anglers in history. Naturally Brielle became a leading center for big-game fishing. Many Brielle-based anglers traveled to compete in tournaments all over the world.

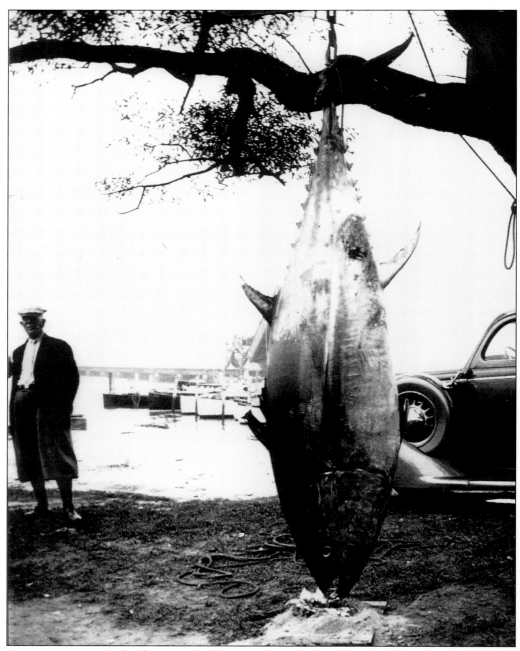

As was customary in the day, a trophy fish is seen here displayed hanging from the tree at Harold Hoffman's anchorage after weigh-in. An onlooker to the left appears to have rushed in from the golf course to marvel at the enormous fish.

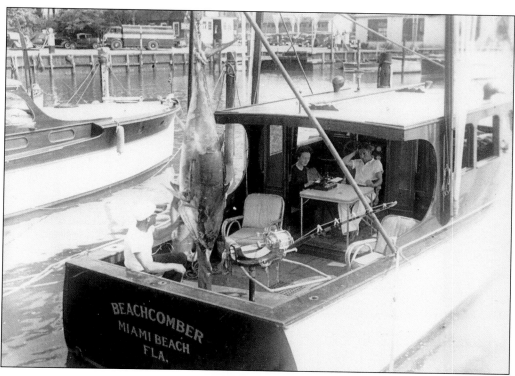

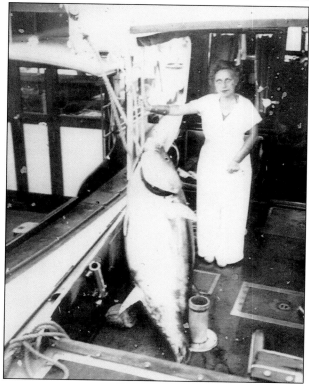

World-renowned fishing duo Lou and Eugenie Marron had established Brielle as a northern base for their fishing exploits by the 1930s. One of their boats is pictured above docked at Feuerbach and Hansen's. At right, Eugenie poses in the cockpit with a good-sized giant tuna.

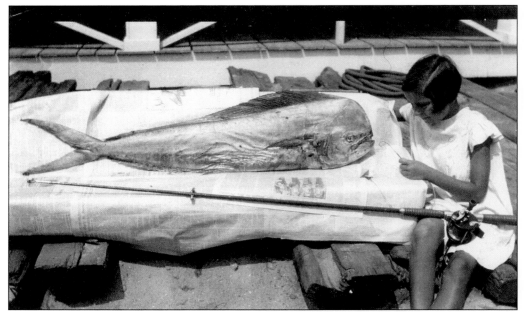

Pretending she caught the dolphin, 10-year-old Janice Felmly Wurfel is pictured in 1933 with her favorite seafood, dolphin, known now as mahimahi. The Atlantic bullnose dolphin is brilliantly colored while alive, and the colors fade quickly after being caught.

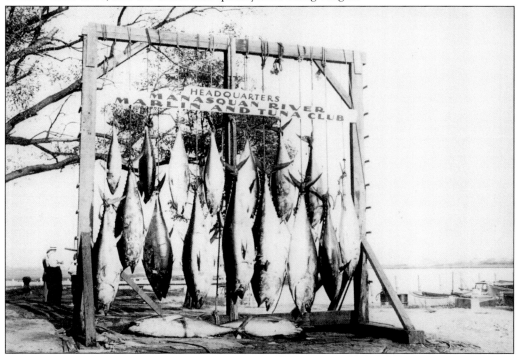

From time to time trophy fish stored at a local icehouse (most likely Seaboard Block Ice in Manasquan) were hauled out and put on display. These fish were most likely prize-winning tuna from a tournament sponsored by the Manasquan River Marlin and Tuna Club.

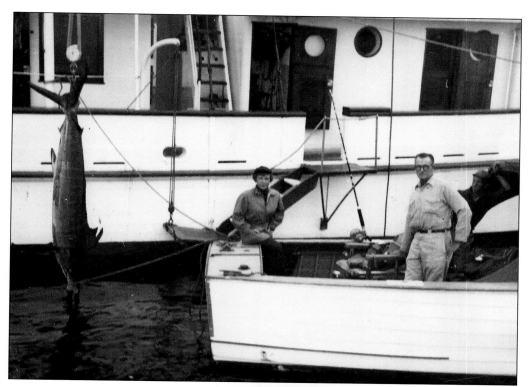

Eugenie Marron poses with a marlin she caught, possibly on light tackle. The Marrons were pioneers in light-tackle fishing, always testing the limits of the newly developed 10-pound to 30-pound test nylon fishing lines. On the right, Lou Marron poses with his captain Clint Thorn (left) and a trophy big-eye tuna caught on heavy tackle hanging from the tree at Hoffman's Anchorage.

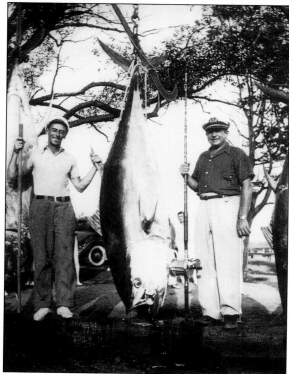

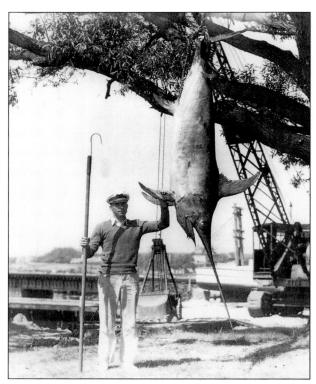

An unidentified angler poses with a broadbill swordfish at Hoffman's Anchorage. Although they are scarce today, in the 1930s and 1940s, swordfish were frequently brought into Brielle.

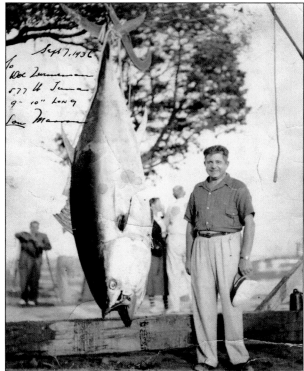

On September 7, 1936, Lou Marron posed with a 577-pound, 9-foot-10-inch tuna at Hoffman's Anchorage. The original photograph is autographed to his father-in-law, Dr. Zwerneman, a Jersey City chiropractor.

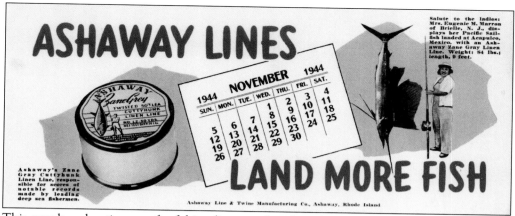

This novelty advertisement for fishing line was found in the memorabilia of Eugenie (Genie) Marron, Brielle's world-renowned "Fisher-Lady." This card features Genie posing with a Pacific sailfish and extols the virtues of Ashaway lines on the front side; the reverse side of the piece is an ink blotter. She was holder of many International Game Fish Association world records in spite of severe arthritis in her hands. Genie's world record 772-pound swordfish, caught on 80-pound test line on June 2, 1954, still stands today.

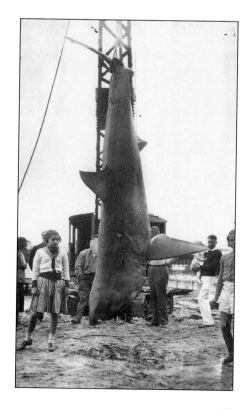

Janice Felmly Wurfel and Bernadette Fitzke are pictured around 1936 at Hoffman's Anchorage with a great white shark.

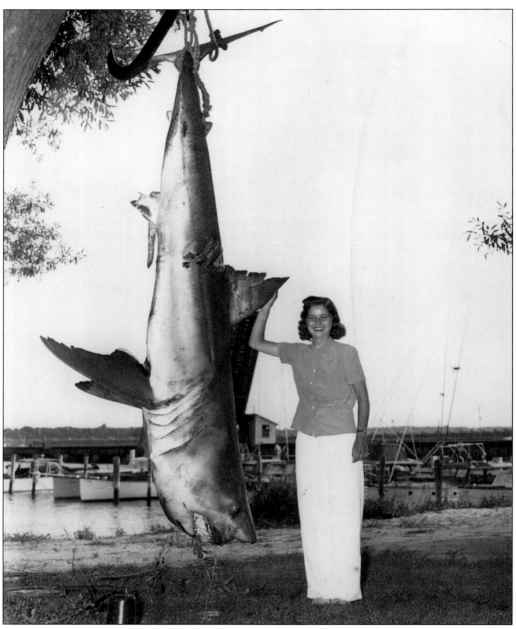

In August 1939, Janice Felmly Wurfel poses with a 998-pound great white shark caught offshore by Francis Low of the Manasquan River Marlin and Tuna Club. Fish this large are secured with a line on the tail and towed inshore backwards, which kills them. During this procedure, they often regurgitate some of their internal organs. Thus this shark would have weighed in excess of 1,000 pounds when caught.

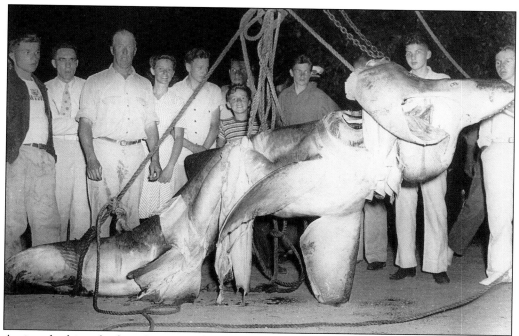

A giant basking shark is shown on display in Brielle. This is mainly a warm-water fish and is quite rare in these waters in any size, let alone a huge specimen like this one. The young boy to the left of the ropes in the center is noted local sign painter John Geiges.

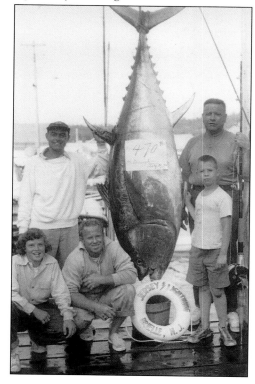

Capt. Sonny Di Fillippo (left), skipper of the *Jersey Lightning*, poses with a 470-pound tuna caught by noted Brielle fisherman Walt McDonnagh (right). McDonnagh was at one time the owner of the Tippecanoe-on-Manasquan log cabin house on Riverview Drive.

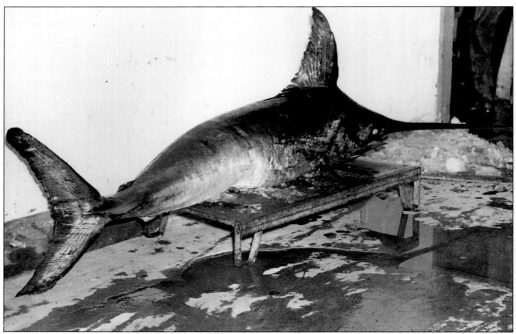

Large fish were often stored in this manner in local icehouses during lengthy tournaments to be judged at a later date. This broadbill swordfish may have earned some lucky angler a trophy in one of the many local tournaments.

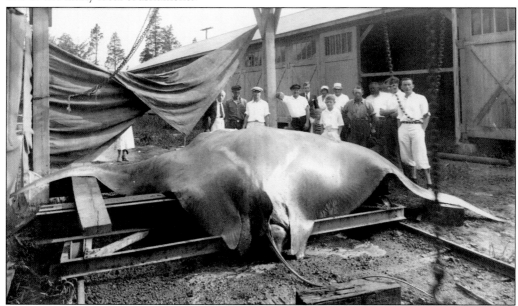

In September 1933, firemen from Brielle Fire Company No. 1 responded to an alarm but found no fire. Instead they found a giant manta ray weighing eight tons and measuring 22 feet across. Caught in the anchor line of a fishing boat, it was towed to shore. The boat owner gave the firemen permission to charge a 10¢ admission to see the sea monster. In six days the firemen raised enough money to make the final payment on a new fire truck.

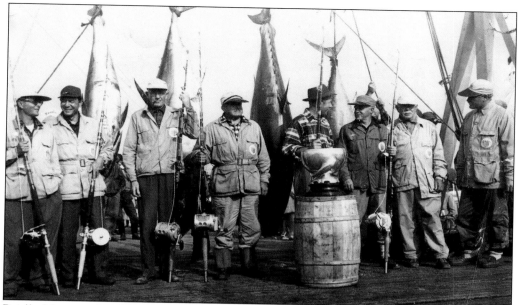

Brielle fisherman Lou Marron was part of the United States team in the International Tuna Cup at Wedgeport, Nova Scotia, in 1949. Pictured from left to right are two unknown team members; Robert B. Montgomery, Rio Hondo, Texas; Louis E. Marron, Brielle, New Jersey; L. Davis Crowninshield, Palm Beach, Florida; unknown; Dr. Leon Storz, Worcester, Massachusetts; and John Manning, Beverly Hills, California.

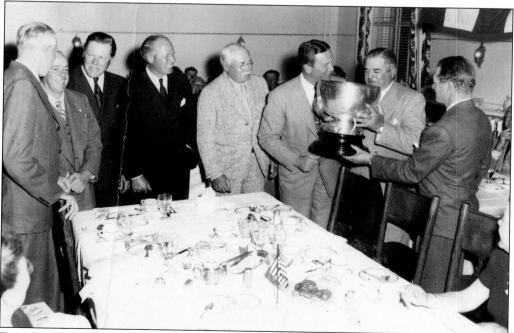

Famed Brielle angler Lou Marron is pictured at the 1949 International Tuna Cup Awards Dinner with his teammates. This tournament was held in Wedgeport, Nova Scotia, in a section of the North Atlantic known as Soldier's Rip.

In the late 1950s, Lou and Eugenie (Genie) Marron sponsored a multiyear scientific expedition with the University of Miami studying billfish along the Pacific Coast of South America. Genie is pictured here with Jo Manning (right) in Ecuador, and Lou poses with John Manning (right). The Marrons and Mannings were responsible for catching most of the fish used for scientific study during the expedition. Genie chronicled this expedition in her book, *Albacora*.

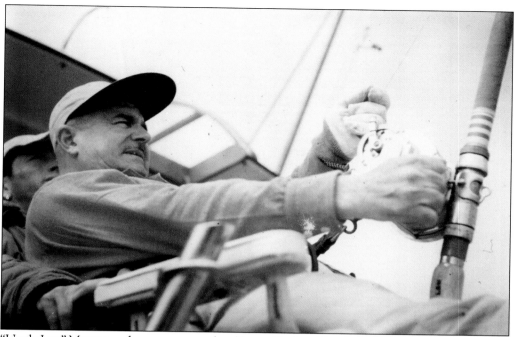

"Uncle Lou" Marron, as he was commonly addressed by local Brielle kids and fellow industrialists alike, is pictured above fighting a broadbill swordfish in 1953 during the South American expedition. During the course of the expedition, Lou caught a world-record 1,182-pound broadbill swordfish. This broadbill swordfish was gaffed and secured with a line to the boat and towed back to shore since it would be too large to fit in the cockpit. Lou's swordfish record from May 7, 1953, remains unbeaten today.

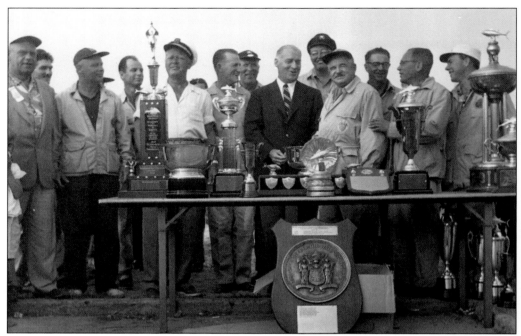

Brielle's Lou Marron was the recipient of many fishing awards and honors; he is pictured here with New Jersey dignitaries and a collection of awards most fishermen could not amass in several lifetimes.

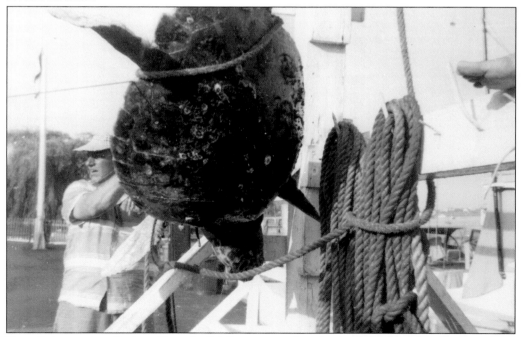

Not all the catches displayed here in Brielle were trophy-winning fish. Occasionally an unusual sea animal or a remarkably sized garbage fish would get caught in a line or net and be brought back to shore and displayed. This green sea turtle turned up at a Brielle dock in 1959.

Six

SPORTFISHING CAPITAL OF THE WORLD

After World War II, automobiles and highways expanded the reach of the American traveler. Previously thought of as being out in the country, Brielle was suddenly not quite so far away from the city. The fishing fleet experienced sluggish times during the war due to threats of U-boat patrols offshore; scarcity of gasoline, metals, and other vital materials; and the fact that fishing boats were sometimes commandeered by the U.S. Navy. Once the country returned to peacetime, the industry picked right up where it left off and continued a period of rapid growth. Tournaments attracted a wide spectrum of participants; postwar prosperity brought more small private boats to Brielle. Some of the large party boats were actually converted war surplus vessels. Dynasties of fishing families arose in Brielle—the Bogans, the Chapmans, and the Shirleys—and more operated fleets of party boats catering to thousands of visitors.

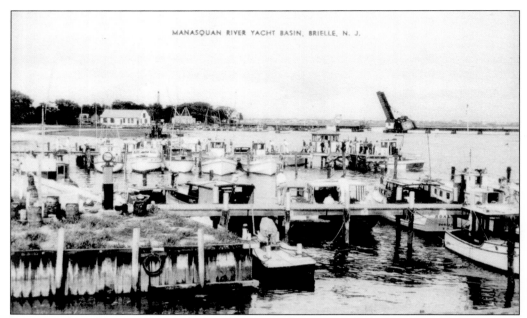

Despite a sluggish period during the tough times of the war, Brielle had now established itself as a world center for sportfishing. The Bogan fleet is pictured here in 1946.

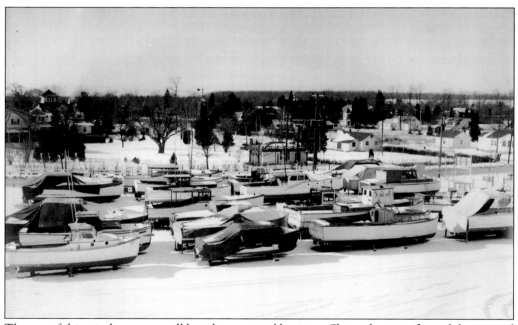

The sportfishing industry was still largely a seasonal business. Shown here is a fleet of charter and private boats laid up for the winter at the Manasquan River Yacht Basin near the intersection of Ashley and Higgins Avenues. The large open field in the upper right is the present site of the Brielle Elementary School. Today deep-sea fishing charters run year round.

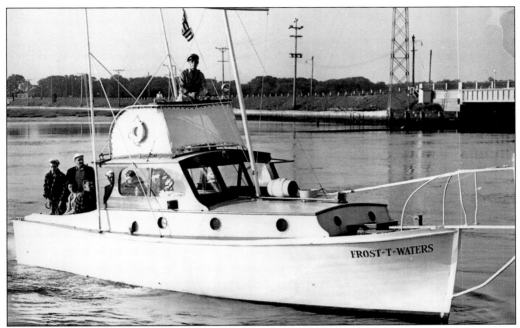

Capt. Howard A. Shirley Sr. ran the *Frost-T-Waters* as a charter fishing boat out of Brielle. Shirley was a building contractor from Maplewood whose family summered in Brielle. Shirley's son, grandson, and nephew continued the tradition and ran the family business for many years.

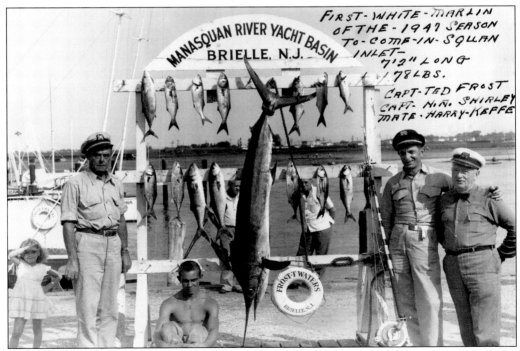

Shirley is pictured left with the first white marlin of the 1947 season. His longtime mate Harry Keffe is seated center.

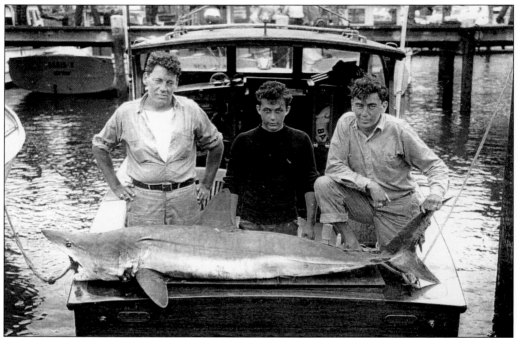

Frank Mundus, right, and party return to the docks in Brielle on board the *Cricket* with a small mako shark. Not all fishing trips in those days returned with a spectacular catch!

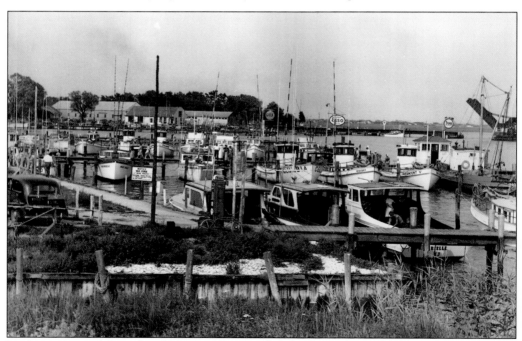

Looking eastward from the old Route 35 automobile bridge in the late 1940s, a substantial fleet of private and charter vessels had developed. The bulkheaded area in the foreground adjacent to the highway was used to launch boats.

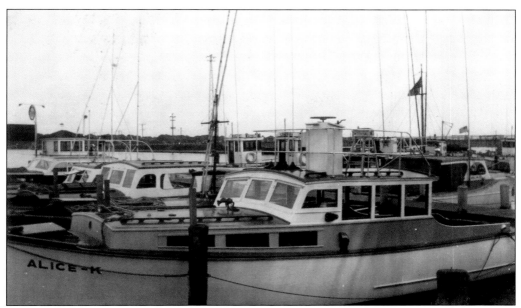

This could be an early morning or evening photograph of charter boats docked when there were no people on the scene. Capt. Donald Keigher owned the *Alice-K*. He also owned and operated a boardinghouse on the opposite side of Ashley Avenue that catered to his fishing customers. By staying overnight, guests would be able to make an early departure the following morning on the boat.

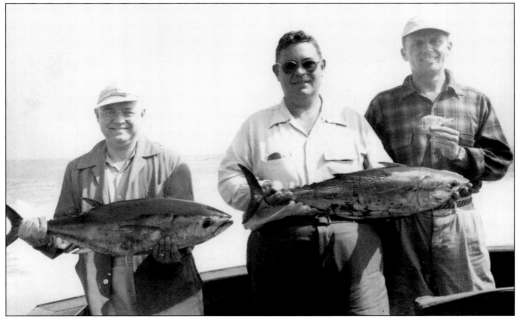

Lloyd M. Felmly (left), editor of the *Newark Evening News*, joined Leroy J. D'Aloia (center) and Fred Schleuter on the *Relaxer*. Municipal judge D'Aloia was the Democratic leader of the Assembly of New Jersey and sheriff of Essex County. The *Relaxer* was owned by the Thermoid Rubber Company of New Jersey.

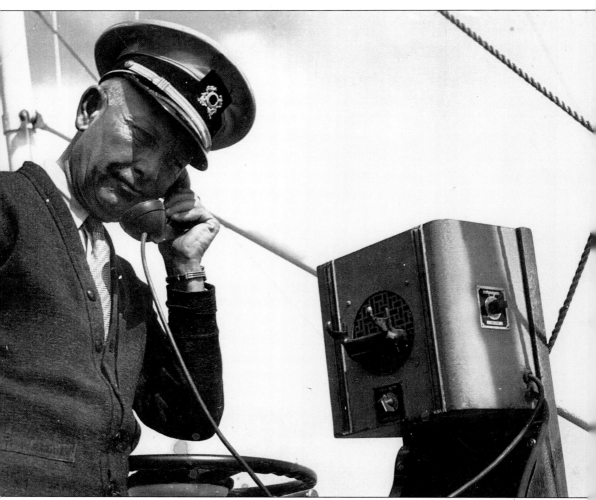

Capt. Sam Good operated charter boats and a boardinghouse known as Sam Good's Place. Good ran the guesthouse until the 1950s. The building was remodeled and still stands today operating as the Union Landing Restaurant.

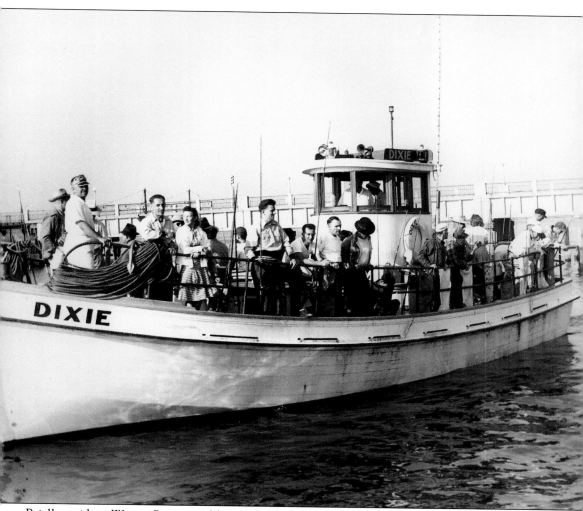

Brielle resident Wayne Pearce and his wife (second and third from left along railing) embark for a day's fishing aboard the *Dixie*, built in 1936. The *Dixie* was owned by the Bogan family and operated by Capt. Howard Duncan. The old Route 35 automobile bridge is seen in the background. A section of this span collapsed in 1946 but was quickly repaired.

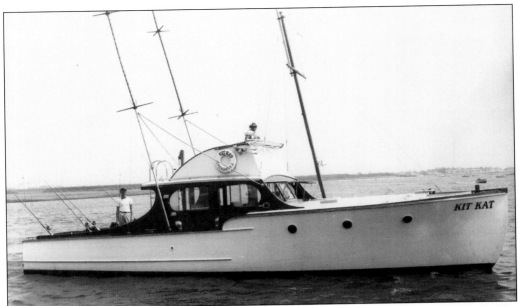

The sportfishing boat *Kit Kat* was owned and operated by Capt. Howard A. "Doc" Shirley Jr. The *Kit Kat* measured 42 feet in length, with a 12-foot beam and 5-foot-4-inch draft, twin Chrysler Royal Specials—200 horsepower each, a Kidde fire control system, a 15-foot teak cockpit, foam rubber cushions, a radio direction finder, a 25-watt ship-to-shore radio, a 12-volt electrical system, a stainless steel galley, a fresh water system, and a 200-gallon fuel tank.

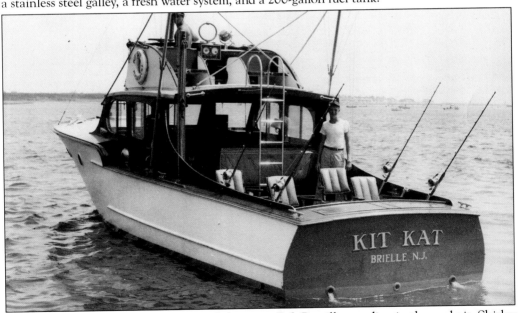

Shirley is at the helm of the *Kit Kat* with his mate Bob Bataille standing in the cockpit. Shirley was a U.S. history teacher at Rahway High School and later became vice principal. He operated his charter boat business during the summers. Bataille was a college student at the time of this photograph and went on to become a professor of English literature at Iowa State University. Bataille is a published author in the area of 18th-century British literature.

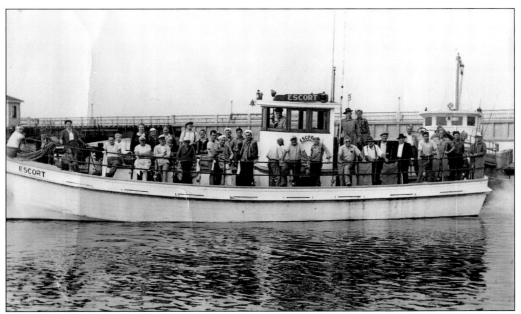

Joseph Mroz and friends spend a day of fishing "down the shore" on the *Escort* out of Brielle. The 46-foot *Escort* was built in 1936 in Brooklyn, New York. The boat would leave the dock in the early morning and return to make a second trip in the afternoon. This was an afternoon departure.

Posing on the stern of the *Margaret K* is Bob Heras, who earned his money for college as a mate in the summer months. Today he installs and services giant cranes for lifting railroad locomotives and trolleys throughout the country.

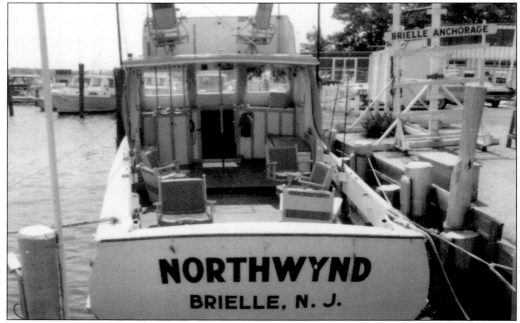

In the 1950s, the charter boat *Northwynd* was owned and operated by Eagle Pharo from Brielle Anchorage. Eagle's son Mike was his first mate. When Mike finished college, he left the fishing business and Eagle's daughter Ginna took over as mate and later earned her captain's license. Today she owns the *Northwynd III* and is still a captain.

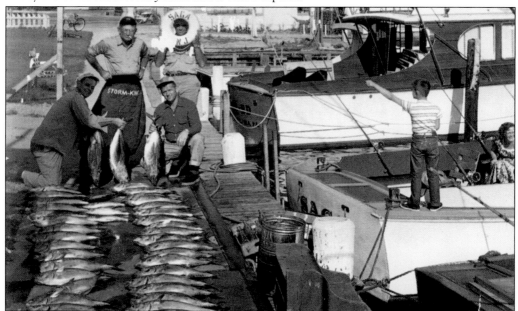

Postcards were often used as advertising for charter boats. This card featuring the *Saga* shows two fishermen with the day's catch of tuna and Eagle hiding behind the life ring. Eagle's wife, Tootie, and young son Mike watched the antics from the stern of the boat. The man holding the "Storm King" jacket is Buzz Garrison trying to get in on the action.

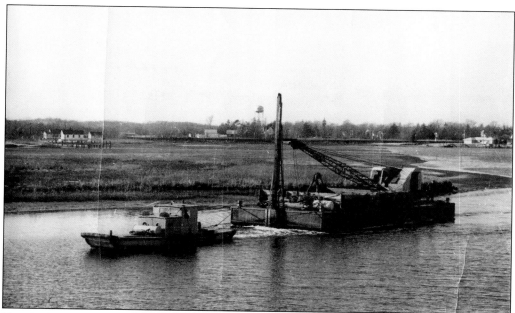

Developing marinas and docks brought a need for marine construction. Many of the marine contractors founded in those early days are still in business today. Here a barge and crane used for bulkhead construction are being towed down the Manasquan River through Brielle.

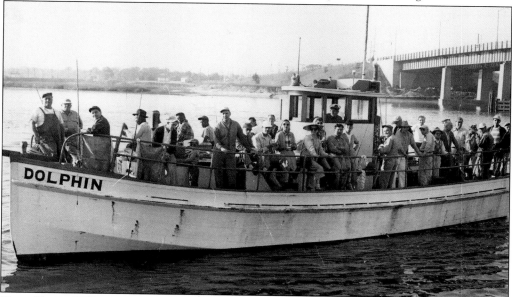

Capt. Henry Hillman operated the *Dolphin* from Bogan's Basin. In the background, note the new elevated Route 35 bridge, built in 1949 and opened in 1950. Equipped with a radio, the *Dolphin* was one of the few vessels permitted to operate during World War II, provided it did double duty as a patrol boat. While on one of these trips, a German U-boat surfaced and the *Dolphin* was boarded. The German sailors commandeered all of Hillman's catch, most of his diesel fuel, and smashed his radio so he could not report the sighting. Hillman and his passengers were released unharmed.

A group of charter boat captains including Capt. Howard A. Shirley Sr. (sitting left wearing captain's hat) stop to chat outside the office of Ziemba's Boat Basin located at the site of the present Brielle Marine Basin. Signs advertise the current fishing tournaments, including the New Jersey Governor's Fresh and Saltwater Fishing Tournament and the Newark Evening News Trophy for giant tuna. The Evening News Tournament was conducted by Ken Lockwood, who wrote an outdoor column for the paper.

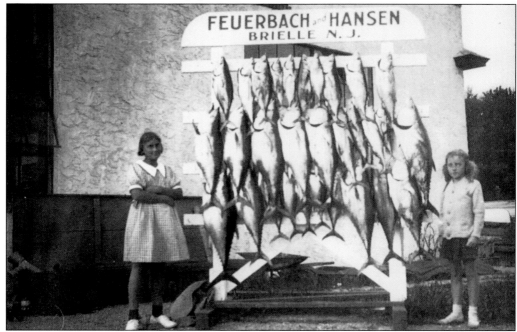

A young Patricia Kroh (left), daughter of Harry Kroh, who served as mayor of Brielle from 1948 to 1949, and future wife of local fisherman Gene Hendricks, poses with a young friend and a boatload of small tuna brought into Feuerbach and Hansen's.

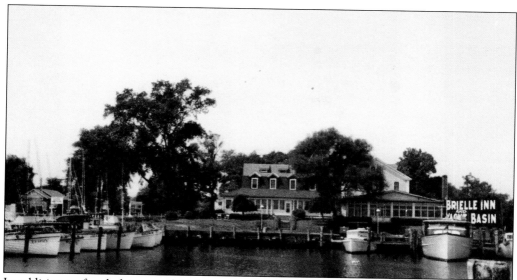

In addition to fine lodgings and dockage, the Brielle Inn had a very popular restaurant known for its fine dining. The restaurant changed hands several times. The land-based restaurant eventually closed and was replaced by a restaurant built on the retired ferryboat *Cranford*, which was towed here and permanently docked at this location in 1962.

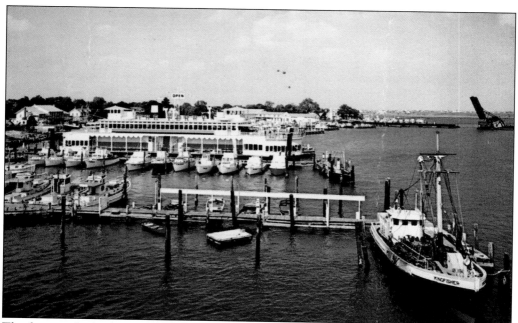

The ferry in the background is the old Jersey Central Railroad passenger ferry *Cranford*, shown here converted into a picturesque floating restaurant and nightclub. *The Kingfisher* was a clammer owned by Clifford Berringer and his brother. The building to the left of the ferry is the Bimini Yacht Club, a popular restaurant that burned on December 2, 1978.

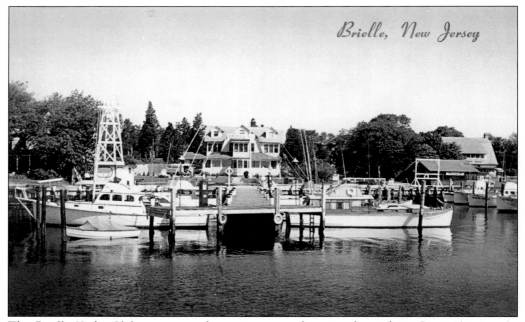

Brielle, New Jersey

The Brielle Yacht Club was a popular restaurant and marina located on Green Avenue. In addition to a restaurant, this site offered a large swimming pool and was the location of many end-of-the-summer Labor Day parties and events. The River House Restaurant is currently located on this site. The smaller building on the right is the service building for the Anchorage Marina.

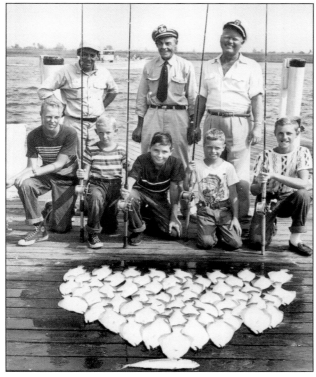

Capt. Howard A. Shirley Sr. and his crew pose with a group of young passengers and their day's catch of fluke at Hoffman's dock. Flatfish like these fluke were much more plentiful in the 1950s than they are today.

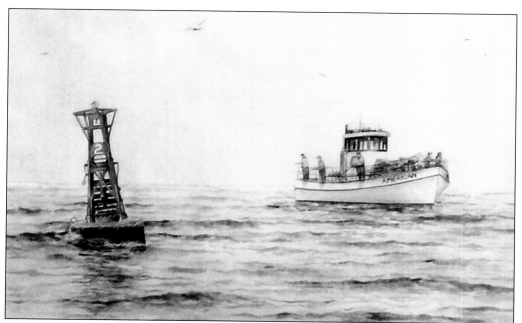

The *American* built by Johnson Brothers Boatworks in Bay Head was a typical bottom fishing boat. This 45-foot vessel was moored at the Manasquan River Yacht Basin. Bottom boats such as the *American* fished for fluke, porgies, sea bass, and so on and also chummed for bluefish. This watercolor by Richard P. Holmquist (around 1968) shows the *American* drifting near the buoy, one mile off Manasquan Inlet.

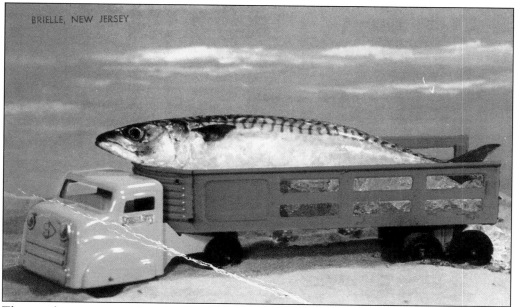

BRIELLE, NEW JERSEY

This is a funny postcard from Brielle. The truck is a toy, and the "catch" is a mackerel, a small baitfish. No doubt the publisher sold the same postcard to fishing communities up and down the coast.

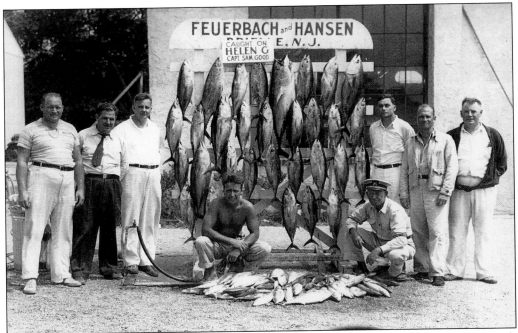

Capt. Sam Good (kneeling on right) and his mate Gene Hendricks (kneeling on left) pose with their passengers from the *Helen G* and their day's catch. Standards of dress were different in those days, as evidenced by the gentleman wearing a dress shirt and tie for a day of fishing.

John Geiges began as a mate on boats at the age of 14. He did some commercial fishing during World War II, served in the Korean War, and followed in his father's footsteps as a sign painter at the age of 26. He is still in that business today.

Seven

LIFE IN SUBURBAN BRIELLE

Throughout the 1940s and 1950s, Brielle, just like many other towns in America, made a transformation into a suburb. The completion of the Garden State Parkway in 1957 connected Brielle to the metropolitan centers of northern New Jersey and New York City in an entirely new way. All at once automobile access was easy and commuting to work many miles away became a way of life for millions of Americans. Brielle experienced a population surge during this time period requiring the construction of a new school building in 1952; the library was expanded in 1953, and a first aid squad was established in 1962. That same population surge spurred the development of new housing on the locations of now-abandoned farms and large estates that were subdivided into smaller residential lots. The circumstance under which the Brielle Land Association transformed Union Landing was made possible by the arrival of rail service. The automobile and highway, not the railroad, were the catalyst for change following World War II.

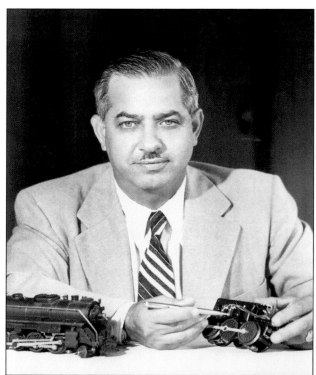

Brielle resident Charles Giaimo invented this little car for Lionel Trains. He was an avid fisherman in spite of suffering from the crippling disease multiple sclerosis. He resided in Brielle for many years along the river and enjoyed fishing as long as he was able.

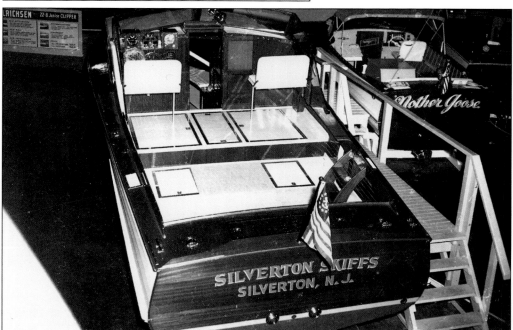

Silverton Skiff's boatworks was purchased in the 1940s by Charles Giaimo. He took the company from a small New Jersey boatbuilder to the major manufacturer it is today. One of Silverton's early models is shown here at an area boat show.

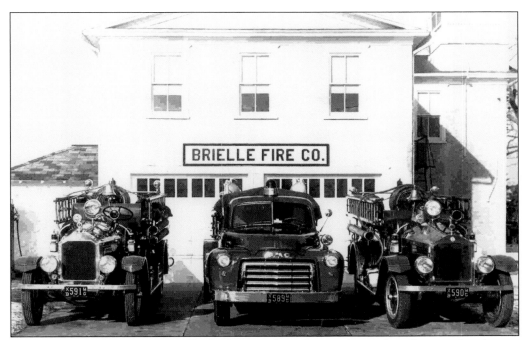

The Brielle Fire Company proudly displays its three fire trucks in this photograph taken in approximately 1951. The newer truck in the center is a 1950 GMC, and the twin trucks are 1928 and 1929 Maxim pumpers. Note the sequential numbers of the three vehicles' license plates.

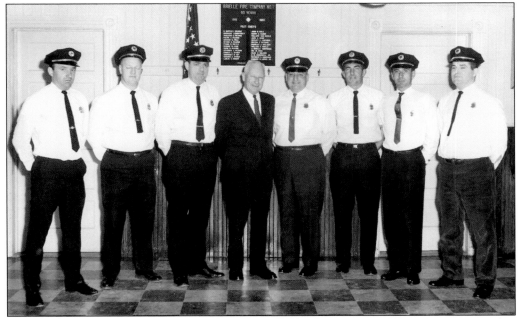

The officers of the Brielle Fire Company are shown here in 1951 with Mayor William F. Crowley. Shown from left to right are Thomas H. Clayton, fire inspector; Henry Bankert, captain; Robert W. Sauer, chief; Crowley; Martin San Giacomo, first assistant chief; Jack Wooley, second assistant chief; Roy McGreevey, first lieutenant; and Edward Burke, second lieutenant.

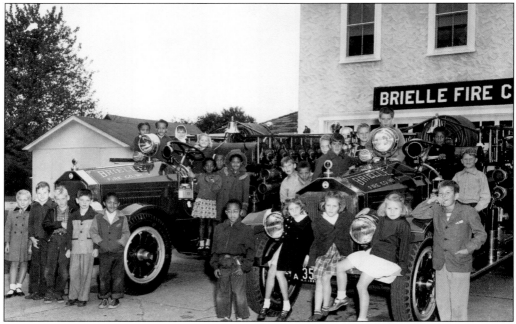

A class trip to the firehouse has always been a popular event for Brielle Elementary School students. These schoolchildren went on a field trip to the firehouse at the corner of Longstreet and Cardeza Avenues in October 1951.

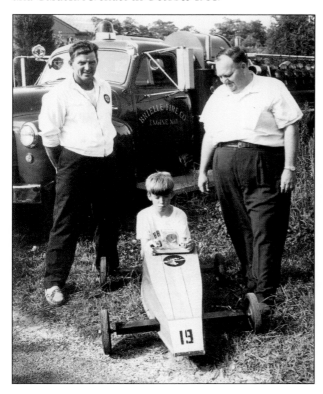

For many years the Brielle Recreation Department sponsored a soapbox derby. The course ran down the hill on Schoolhouse Road toward South Street. Pictured here are Snooky Hoenge (left) and Ed Smith (right) with the 1969 champion.

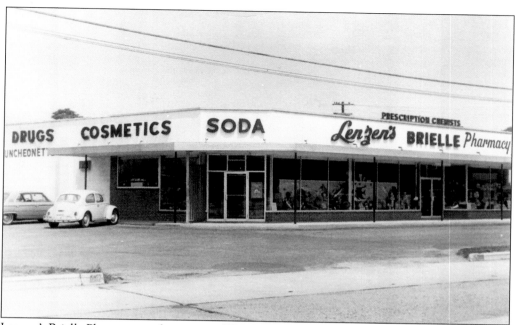

Lenzen's Brielle Pharmacy at the corner of Higgins and Riverview Drive was a prominent Brielle business for many years. The Lenzen family owned and operated the pharmacy from 1961 to 1983. The site now houses several retail stores.

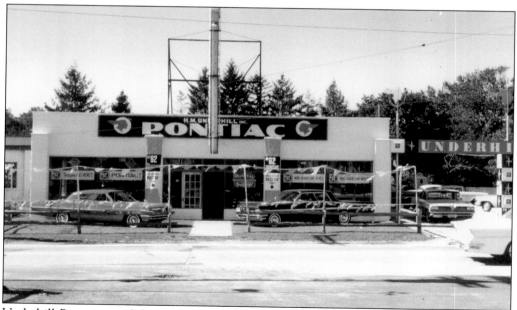

Underhill Pontiac stood diagonally across the intersection from Brielle Pharmacy. H. Melvin Underhill proudly displays the new 1962 Pontiac line in this photograph. Underhill eventually sold the dealership, and it became a used car dealership. It was later converted to a professional office complex, which is located on the site today.

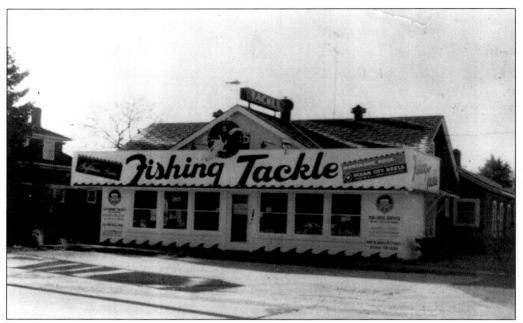

Pictured here is Walt Johnson's bait and tackle shop on Higgins Avenue in about 1956. The shop catered to the needs of local fishermen for many years. Located across from the present post office, the tackle shop is now gone, but several other businesses have occupied the building, which still stands today.

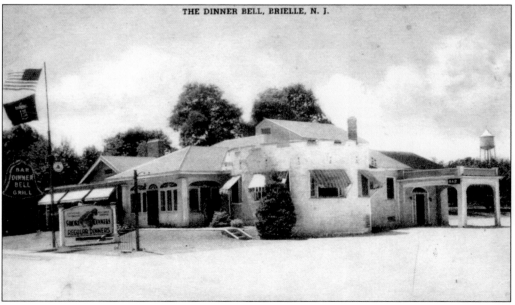

The Dinner Bell was a popular restaurant in Brielle from the 1930s until 1972 located on Union Avenue. It was known since then as Steer and Spirits, Brielle Inn, and L.T.'s, among other names. The initials "L.T." stood for Lawrence Taylor, a linebacker for the New York Giants and owner of the restaurant for a short time. Today it is Charlie Brown's Steakhouse. Despite extensive remodeling, one can see the same basic shape of the structure today.

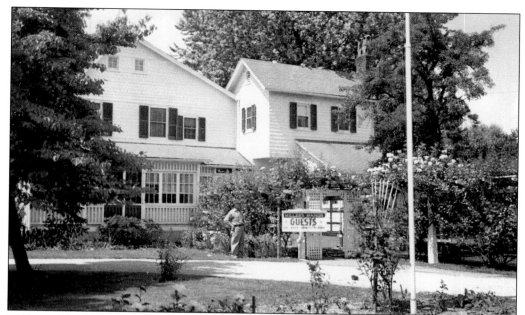

Miller's Manor Guesthouse was located at the corner of Union Avenue and Union Lane across from the present borough hall. It was operated by the Millers as a guesthouse catering to overnight fishing guests well into the 1950s. Before the Millers owned this property, it was the summer residence of the Dusenberry family from Newark.

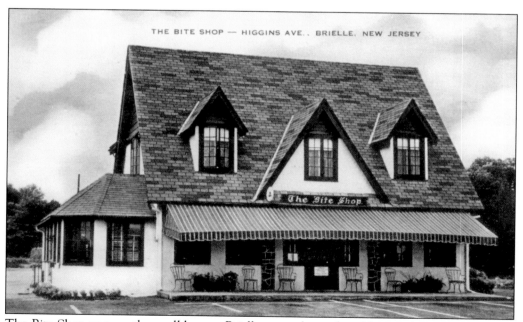

The Bite Shop was another well-known Brielle eatery located on Higgins Avenue across from Eloise's Café today. The owner Eva C. Bissett had a very talkative parrot that was popular with the diners. The restaurant closed in the early 1960s and was remodeled into a real estate office. Currently this site houses professional offices.

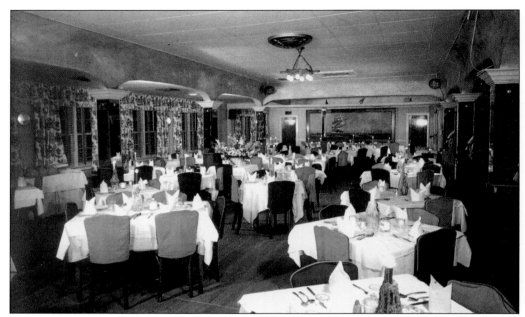

Many tourists remember the Ship Wheel Inn as one of the few establishments open late in the off-season. A shuffleboard table in the bar was a popular attraction. Originally built in the 1930s, the restaurant has changed hands and was remodeled several times. The present owner remodeled the interior, and the result was remarkably similar to the original decor pictured above. It is the present site of Simko's Grill on Higgins Avenue.

This building is the former retail outlet of Loughran Gardens, a commercial flower farm located in what is now Brielle Park. After a major fire, the building remained vacant for many years, then it was taken over by the borough and remodeled to house the Brielle Public Library, previously located in the basement of the present borough hall.

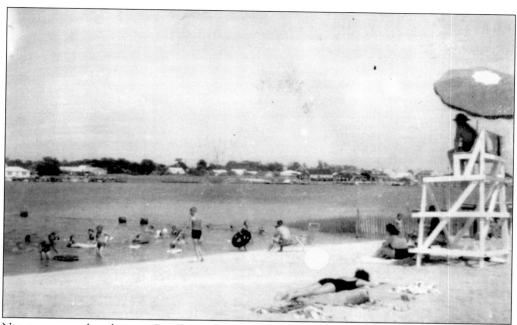

Not too many decades ago, Brielle residents enjoyed a wide sandy beach on a tributary of the Manasquan River called the Glimmer Glass. The beach was located on East Magnolia Avenue adjacent to the railroad tracks. The Brielle Recreation Department provided lifeguards to ensure the safety of bathers.

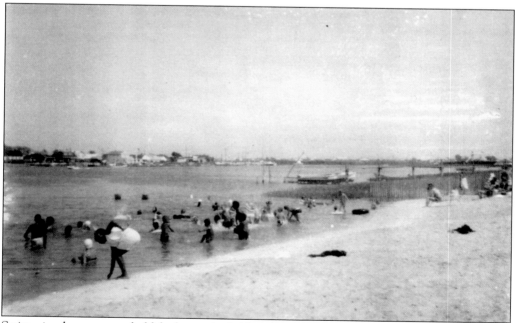

Swimming lessons were held for borough children here during the summer months. The Brielle Playground, forerunner of today's summer recreation program, sponsored a wide range of water recreation activities. This area had fallen into disuse and became very overgrown. There is an initiative today to restore this area to a working recreational facility.

BRIELLE PLAYGROUND

This certifies that

.......... *Neil* *Wilson*

has completed the *ad. beginner* course of
instruction in swimming at Brielle Playground,
Brielle, N. J.

.......... *July 20, 1964* *Nicholas Stavres*
 date director

...
 holder's signature

The Brielle Playground provided recreational and creative activities for children during the summer months. Pictured above is a swimming certification card, which was awarded to students at several skill levels. Children participated in organized sports like the dodge ball tournament pictured below and made arts and crafts throughout the summer months.

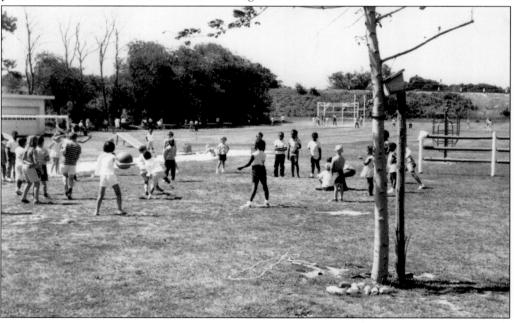

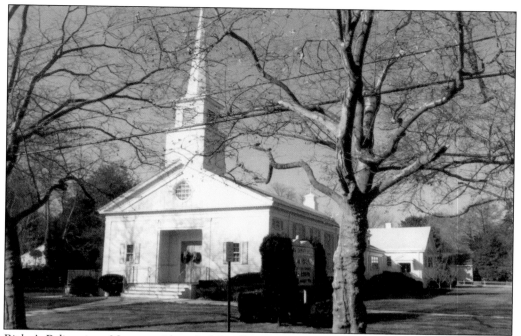

Ripley's Believe it or Not once identified Brielle as a town with "16 bars and no churches." That all changed in 1957 with the construction of the Church in Brielle a branch of the Reformed Church in America (pictured above). The congregation expanded, and in 1968, an addition was constructed to the church connecting the sanctuary and religious education building together.

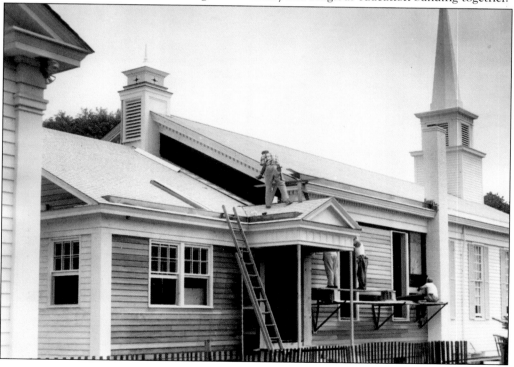

Every December ladies of the Church in Brielle conduct the popular holiday bazaar. Vendors offer jewelry, crafts, and gift items for sale. Proceeds of the sale benefit the church. Pictured here are two charter members of the church, Dorothy Statesir (standing second from left) and Florence Randolph (seated left) along with Betty McCorkle (far right). Statesir celebrated her 100th birthday in 2006.

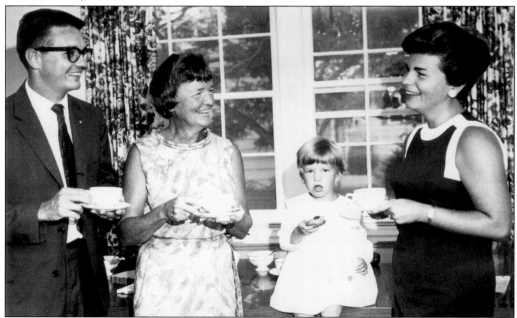

In 1967, the Church in Brielle established a nursery school that remains well attended to this day. Pictured above from left to right are the Reverend Randall B. Bosch; the new nursery school director Mrs. Walter Fornoff; and Carole Wall, chairman of the nursery school committee. The little girl is Wall's daughter Susan, who is currently a Sunday school teacher at the church.

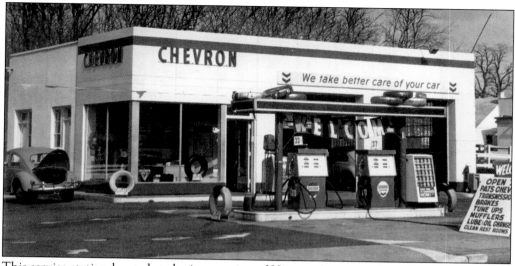

This service station located at the intersection of Higgins Avenue and Riverview Drive served borough residents for many years. The pumps offering gasoline at 33¢ and 37¢ per gallon are now unfortunately removed, and this business currently operates as Brielle Service Center.

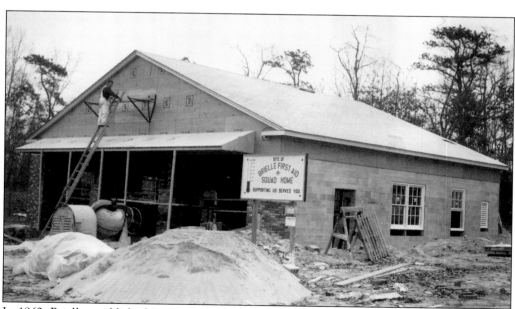

In 1962, Brielle established its very own first aid squad. Previously the area had been served by the Manasquan First Aid Squad. Initially the Brielle squad did not have a permanent home. Extensive fund-raising financed construction of a home for the squad, which began in 1965, on Old Bridge Road.

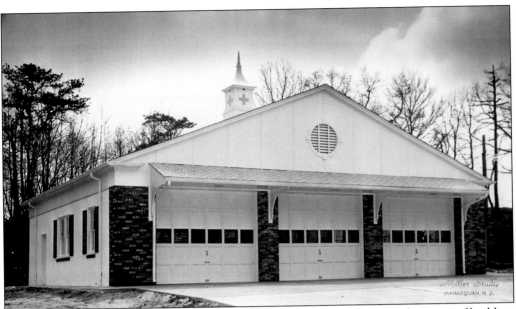

The first aid squad building is pictured here as it appeared in 1967 when the first stage of building was completed. The building has been further expanded to include a rental hall in the rear and additional storage space.

From left to right, participants in the dedication of the first aid squad building are (seated) Marion Chappelle, secretary, and Carmen Ferrell, reception committee; (standing) Snook Hoenge, first lieutenant and chair of the building committee; Betty Biringer, chair of the dedication program; Harry Biringer, captain; and Jack Legg, vice president of the squad.

Members of the women's auxiliary of Brielle's Buchanon-Foster-Stone VFW Post present one of the first heart monitors to members of the Brielle First Aid Squad in 1974. Pictured from left to right are Lorraine Morgan Lyons, Roselle Morgan Travis, Emma Hancock, Larry Morgan, and Herb Strucek.

This marker commemorates the settlement of Lenape Indians who summered in this area for thousands of years. In the early 1970s, the Brielle Environmental Commission sponsored an archaeological dig led by Dr. Herbert Kraft and John Cavallo. The artifacts they recovered shed light on the culture of the first inhabitants of this area. The site was excavated again in 2005 by archeologist Charles Bello.

Brielle Environmental Commission chairman Richard L. Scott presents an award to Mrs. Howard W. Bruce and the Woman's Club of Brielle recognizing their support of the commission's project to conduct an archaeological survey of the Native American settlement near Birch Drive. Pictured from left to right are Mrs. Phillip C. Shaak, Mrs. Louis W. Adam, Bruce, Scott, and John Cavallo, archaeological instructor at Middlesex County College.

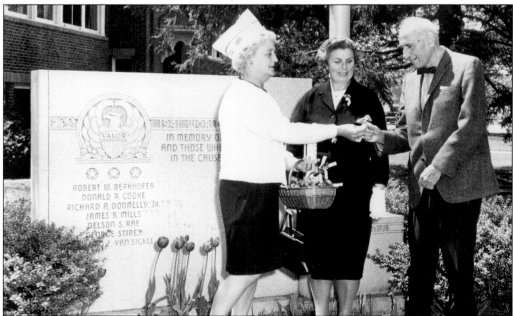

Retired army colonel Dee W. Stone and his wife purchase the first poppy from Thelma Cichanowicz, poppy chairman of the Brielle VFW Post shortly before Memorial Day 1967. The Stone's son 1st Lt. Dee W. Stone Jr. was killed in action on November 11, 1966, in Vietnam and was one of the namesakes of the post.

Eight

BRIELLE'S GOLDEN ANNIVERSARY

In 1969, the Borough of Brielle celebrated a significant milestone, its 50th anniversary of incorporation. Dozens of dedicated residents joined together to form committees to plan the yearlong celebration. Dinner dances, parades, golf and fishing tournaments, contests, and yachting regattas were planned and executed. Dignitaries and special guests participated in all facets of the ceremonies. At the same time, Brielle found itself with an unexpected celebrity in town; Brielle resident Col. Edwin Aldrin Sr.'s son Edwin "Buzz" Aldrin Jr. became the second man to walk on the moon on July 20, 1969. Although not technically a Brielle resident, Buzz visited his parents and sister here frequently.

50th

Anniversary Celebration

1919 — 1969

BOROUGH OF BRIELLE, NEW JERSEY

Incorporated April 19, 1919

Before incorporation Brielle was a part of Wall Township. Earlier records tell us that our present Borough was originally called Union Landing.

The year 1969 marked Brielle's 50th anniversary of incorporation. The prior year a committee was formed to plan and execute a yearlong celebration.

SCHEDULE OF EVENTS
Brielle Golden Anniversary Celebration - 1969

April 18	Opening Ceremonies	Brielle Elementary School
April 21-26	Art Show (open during store hours)	Brielle Furniture Store, Highway 70
May 17	Kite Contest	Brielle School Field
May 22	Bayberry Club Flower Show	Manas. River Yacht Club
June 14	Junior Fishing Contest	
June 14	Golden Anniversary Dinner Dance	Manasquan River Golf Club
June 15 to September 15	Adult Fishing Contest	
June 16, 17, 18, 19	New Jersey State Amateur Golf Championship Finals	Manasquan River Golf Club
June 21	The Woman's Club of Brielle Fair and Pet Show	Higgins Avenue
July 11	Teen Dance	Brielle School Auditorium
July 19	Field Activities	Brielle School Field
August 15	Beauty Contest	Brielle School Auditorium
August 15	Baby Parade	Brielle School Auditorium
August 16	Golden Anniversary Dance 9 p.m.	Manas. River Yacht Club
August 23	Glider Contest	Brielle School Auditorium
August 31	Fiftieth Anniversary Regatta	Manas. River Yacht Club
September 6	Swimming Meet	Manas. River Yacht Club
September 6	Tennis Tournament	Manas. River Yacht Club
September 20	Veterans' Memorial Service 10:45 a.m. at Brielle Borough Hall Monument by Officers and members of Buchanan, Foster, Stone Memorial Post No. 10103, Veterans of Foreign Wars.	
September 20	11:00 a.m. Grand Parade and Firemen's Day Picnic featuring Antique Auto Club, Boy Scouts, Girl Scouts, Community Organizations, First Aid Units, Police Units and Fire Companies from Monmouth, Ocean and nearby Counties. Brielle Fire Department will announce complete details through press and radio.	

An extensive schedule of events was planned, including an art show, dinner dances, fishing contests, sporting events, and exhibitions, and concluded with a veteran's memorial service and parade. The committee also published a commemorative booklet showcasing many businesses, organizations, and activities in Brielle.

Brielle resident Col. Edwin Aldrin Sr., father of astronaut Buzz Aldrin (who visited Brielle frequently), participates in the flag-raising ceremony at the concluding ceremonies of Brielle's golden anniversary on September 20, 1969. Pictured with the colonel from left to right are Mayor Jesse Collinson, councilman Don Havens, anniversary committee chairman George G. Goodfellow, and George Davis.

Mayor Jesse Collinson and Eden "Skeeter" O'Hara, commander of the Brielle VFW Post, place a memorial wreath honoring the veterans at the monument located in front of the present borough hall on the corner of Union Avenue and Union Lane. This monument honors the memory of Brielle residents killed or missing in action during World War II.

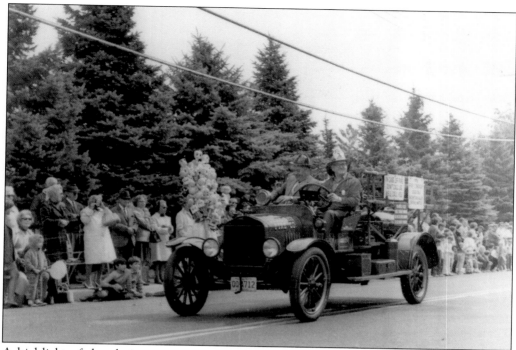

A highlight of the closing ceremonies was an elaborate parade featuring fire and emergency vehicles from all over Monmouth and Ocean Counties. Other participants included school, community, and scouting organizations from Brielle and surrounding towns.

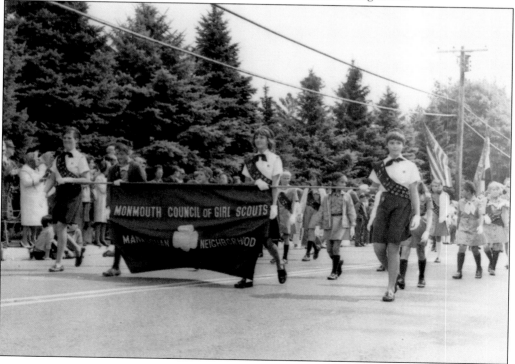

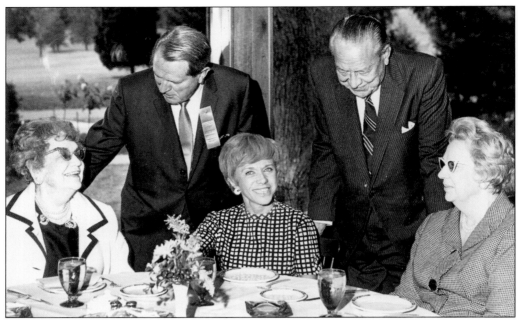

Brielle resident Eugenie Marron is pictured seated center at the 50th anniversary closing dinner. She is joined on the right by Mary Roebling, chairman of Trenton Bank and Trust, and on the left by Washington socialite Perle Mesta, best known as the "Hostess with the Mostes." Anniversary committee chairman George Goodfellow stands to the left behind Marron.

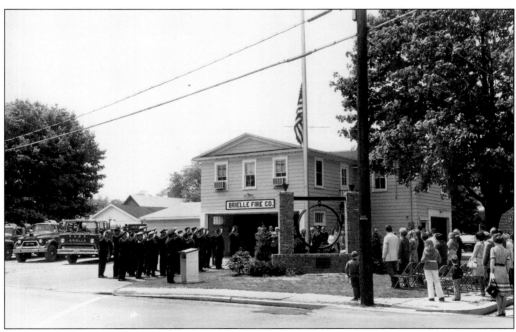

Members of Brielle Fire Company No. 1 take part in a ceremony dedicating a monument in honor of distinguished member Henry Melvin Underhill Jr. A World War II U.S. Navy veteran, Underhill served as chief in 1956 and as president from 1965 until his death in 1970.

Nine

"IT NEVER RAINS ON BRIELLE DAY"

Local lore states that "It never rains on Brielle Day," and since the first Brielle Day on September 8, 1973, that maxim has remained true. Brielle Day is always the first Saturday after Labor Day and was conceived by councilman (later mayor) Robert J. Collinson. Collinson's idea was to create a sort of "community day" event in which all of the town's organizations could participate and benefit either financially or aesthetically. The date was chosen to be after school was in session to ensure there would be a substantial local turnout, since the event was initially targeted toward residents. Nonprofit organizations, including the Women's Club of Brielle, Brielle Fire Company, Brielle First Aid Squad, Union Landing Historical Society, Boy and Girl Scouts, Bayberry Garden Club, and Riverview Seniors, are major participants in the event. These groups stage special events and operate food and drink concessions to raise money for themselves and reinforce the tremendous sense of community that has always existed here in Brielle. A now-extensive craft fair that features dozens of crafters and artisans joins these core groups. The Union Landing Historical Society originally hosted them, but in later years the Women's Club of Brielle has taken charge of that portion of the activities. What began in 1973 as a primarily local event now attracts over 20,000 attendees each year.

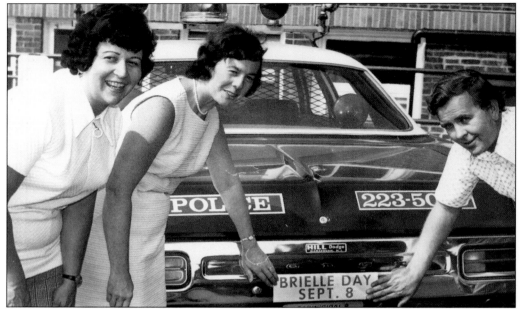

Early publicity is shown for the first Brielle Day held on Saturday, September 8, 1973. Pictured from left to right are Lyn O'Neill, Marge Covey, and councilman (later mayor) Bob Collinson promoting the first Brielle Day with a bumper sticker on one of Brielle Police Department's patrol cars. Collinson was the originator of Brielle Day.

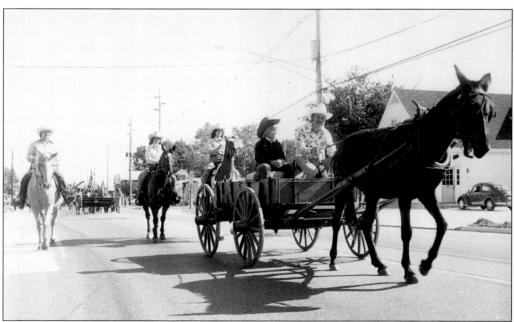

Earlier Brielle Days began with a parade featuring marching bands and organizations from Brielle and neighboring towns. This photograph is from Brielle Day 1976. Today the Brielle Hill and Dale 10K race is the kick-off event at Brielle Day. At other times Brielle Day featured a bicycle race sponsored by Brielle Cyclery.

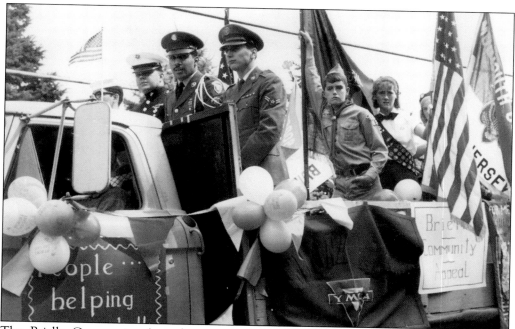

The Brielle Community Appeal, an organization formed to support community welfare, sponsored this Brielle Day parade float honoring servicemen and Scouts.

In its display each Brielle Day, the Brielle Environmental Commission showcases the activities of its projects and provides information about Brielle's natural resources. The Brielle Environmental Commission was formed in 1973 in response to a growing sense of environmental conscience throughout the state of New Jersey. In 1978, the commission published an extensive survey of Brielle's natural resources.

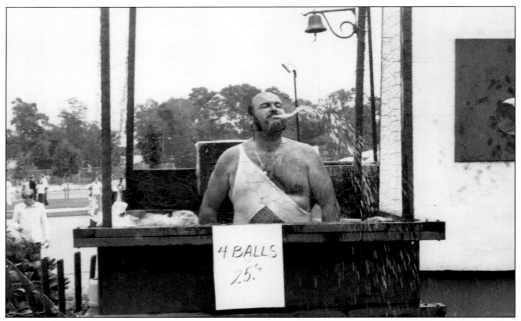

The Brielle Fire Company has always played an active part in each and every Brielle Day. The fire company's activities include the beer garden and sale of their famous roast beef sandwiches. Both are substantial fund-raisers for the fire company. Firefighter Neil Lomax mans the fire company dunking booth at Brielle Day 1976.

Mrs. Edward L. Whitehead watches as Raymond J. Arrowsmith demonstrates caning on a chair seat. Craftsmen like Arrowsmith have always been part of the large craft fair that takes place on Brielle Day.

Duck decoy carver Dick Lang demonstrates his craft and sells his wares on Brielle Day 1978. Crafts like this are rarely seen outside events like Brielle Day, except for waterfowl and decoy shows, popular all along the eastern seaboard.

Brielle Day means fun for all ages! Activities for children have always been popular on Brielle Day. Pony rides in 1976 are shown here. The Brielle Fire Company offers rides for children in a fire truck. Troop 63, Boy Scouts, erect a rope bridge obstacle course and the Pack 63, Cub Scouts, sponsor a bottle toss game with prizes.

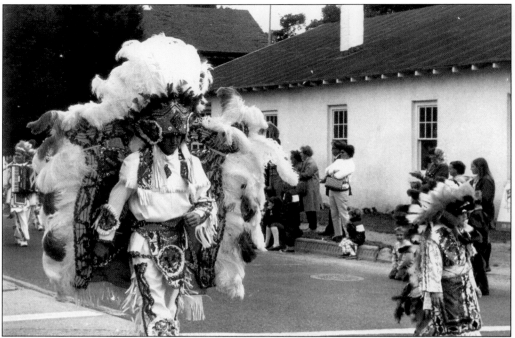

The parades of early Brielle Days drew marching bands from many local schools. Mummers and their string band are seen here marching in an early parade.

The array of crafters and vendors offering unique items for sale has grown considerably since the first Brielle Day. This is due to the Women's Club of Brielle's skill in organizing this part of the event each year. The annual event, which occurs the Saturday after Labor Day weekend, attracts over 20,000 attendees.

Ten

A COMMUNITY
BY THE RIVER

Like many other New Jersey towns, the population and general character of Brielle has experienced a steady ebb and flow throughout the years. Unlike many others, Brielle's changes have always been both positive and productive. There was never an industry or manufacturer that left the area with an economic void and created a ghost town. Brielle and its residents have always made the cycles of change work for them in a positive manner. As each older generation grows up and moves away, more young people move into town. Some families have remained here for decades, each succeeding generation continuing to enjoy the experiences offered by life at the Jersey Shore in Brielle. Brielle's population has experienced a steady growth in recent decades, and each generation does its part to add to the quality of life in Brielle. The sense of community under which Brielle was created by the original developers has never left.

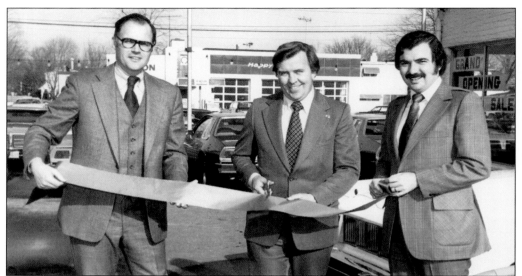

Established in 1937, the Brielle Chamber of Commerce helps promote new businesses in town by participating in ribbon-cutting ceremonies. In 1976, Marty Cammarano, new owner of Brielle Motors located at the corner of Riverview Drive and Higgins Avenue, is joined by Mayor Robert J. Collinson and Tom Ratcliffe. The chamber, nicknamed the "Good Neighbor Group," remains strong today with over 100 active members. Additional annual activities include a fishing tournament and the sale of a limited-edition ornament commemorating a Brielle event or location.

When this picture was taken in April 1977, the Church in Brielle Nursery School had become a community institution. Pictured here are John Viscegelia, a current member of the Brielle Board of Adjustment and Brielle Fire Company, and classmate Michele Irwin being served cupcakes by Patricia Gibbs, currently a kindergarten teacher at Brielle Elementary School. The school enrolls nearly 100 students each year in its nursery and preschool programs.

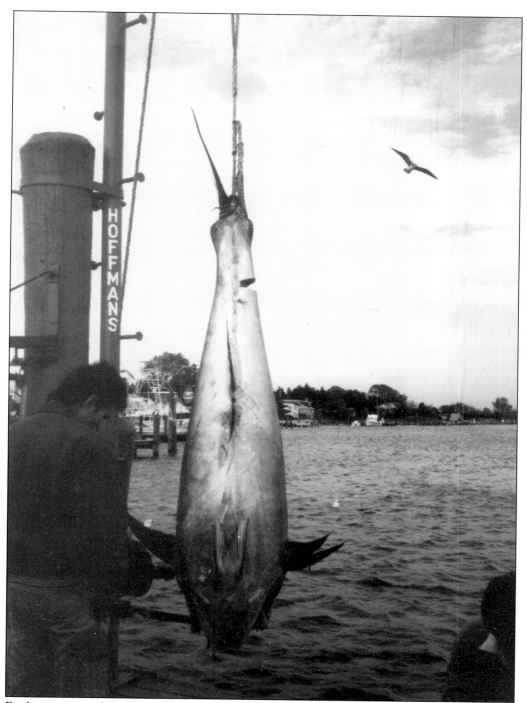

Fresh giant tuna for sashimi is a highly sought after commodity in Japan. A buyer from Japan taste tests the tuna prior to purchasing it from a local fisherman at Hoffman's Anchorage. After the sale, this fish was packed in ice in a large wooden box and flown to Japan via Newark Airport. This tuna was for sale in Japan within 24 hours of being brought into the dock.

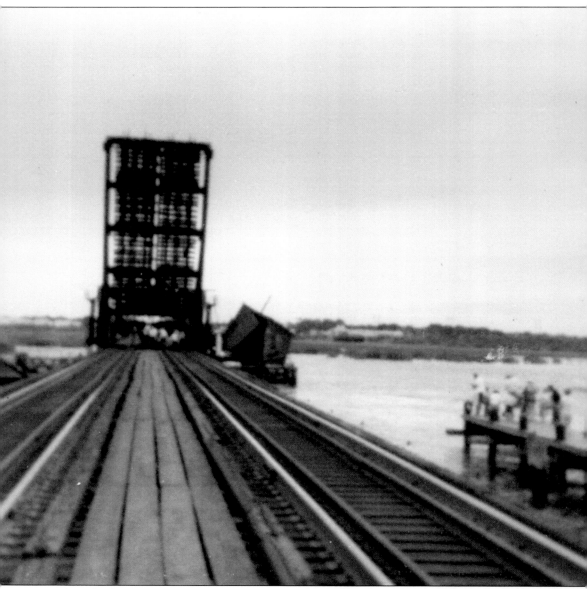

When the ferryboat *Cranford* was brought to the Brielle Inn Marina in 1962, it caused significant damage to the railroad bridge. The line was completely closed for several days, inconveniencing many commuters while the bridge was repaired. When the ferry was towed out to sea in 1982, its hull was stripped completely to make absolutely certain there would not be a repeat of the inbound accident. The *Cranford* was intentionally sunk off Sea Girt as part of the New Jersey Artificial Reef Program.

A young Bob Matthews poses with
Capt. Skeet Frink (left) and T. Banano
(right). Many fishing boat captains like
Matthews got their start hanging around
the local docks and working as mates
on fishing boats. The trio poses with
a 283-pound swordfish caught just a
quarter mile off Bay Head in 1975.

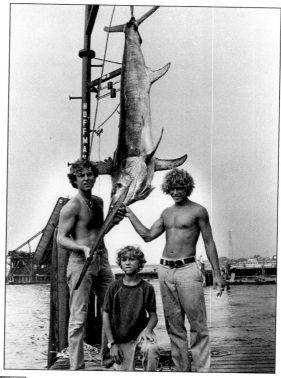

Jim Packer is among the third generation of
his family to enjoy fishing in Brielle. The
family home is on Green Avenue. Packer is
with his friend Tony Baker and a 37-pound
striper caught from his boat the *A-Luring*.
The next generations of his family
continue to return to Brielle to fish.

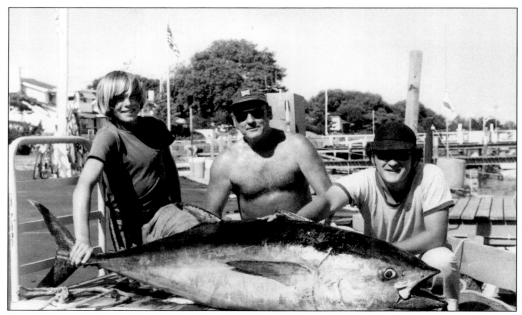

Capt. Howard "Doc" Shirley Jr. is pictured here. In 1976, he was still active in his family's sportfishing charter business. Joining him with a large tuna are his two mates Timmy Birch (left) and Ross Fisher (right). Fisher is now retired from the U.S. Navy where he flew A-7s from the aircraft carrier *John F. Kennedy*. He is currently president of Miami Air and sill flying today.

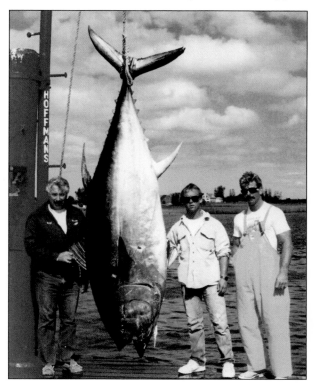

Bob Matthews (center), previously pictured as a mate, is now a private boat captain. He poses with a giant tuna caught by George Harms on the *Low Bid* in 1984.

Throughout the 1970s and into the 1980s, offshore power boat racing attracted scores of tourists and race enthusiasts to Brielle and surrounding communities. Race boats like the one pictured here would use Brielle marinas as launching points into the Manasquan River. Weeklong race festivities included boat parades and trophy dinners and provided a tremendous boost to local businesses.

Although a race boat is a precision machine, technical difficulties do befall crews prior to races. The *Streaker*, shown here, began to take on water on its way out to the racecourse. The crew beached the boat behind a Green Avenue home. The Coast Guard responded with pumps to bail out the sinking boat. It was then towed away for dry-dock repairs.

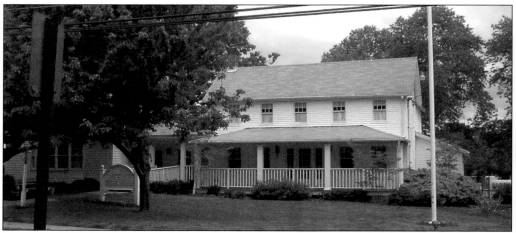

Fred Curtis owned and operated a gladiola farm on Union Lane. Following his death, the borough purchased the home and property in 1968 for use as Brielle's community center. The right side of the building is the original Curtis farmhouse. The left side of the building was added on in 1971 and encloses a large open meeting room. The Curtis House also served as a temporary overflow location for the Brielle Elementary School. Brielle organizations, including the Union Landing Historical Society, the Riverview Seniors, the Women's Club of Brielle, the Bayberry Garden Club, and Scouting groups, all call the Curtis House home for their meetings throughout the year. This well-maintained facility offers seating for over 150 people, a fully equipped kitchen, storage space, and room for activities. The Union Landing Historical Society also transforms the Curtis House into Brielle's History Museum each Brielle Day.

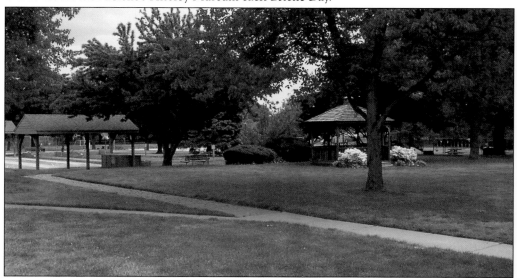

When state Green Acres funding became available in the early 1970s, the borough purchased the Loughran Gardens' property and several of the surrounding houses, cleared the land, and dedicated it as Brielle Park on September 6, 1975. A few houses were demolished, but one enterprising resident purchased one of the homes from the borough for $1 provided he moved the house to another location. He did, and the house still stands today at 704 Schoolhouse Road. The Loughran Gardens retail showroom was renovated by the borough in 1987 to be the new home of the Brielle Public Library. The building opened to the public on February 29, 1988.

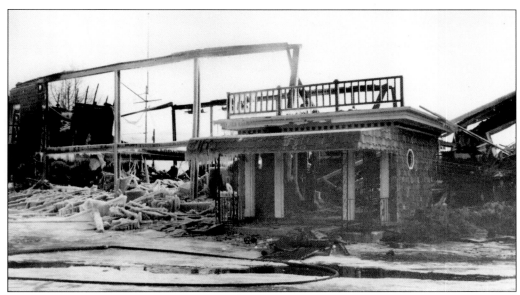

On the night of December 2, 1976, the famous Bimini Yacht Club restaurant was destroyed by fire. Firefighters from Brielle and five neighboring towns battled the blaze in the frigid winter air late into the night. A group of trapped patrons was rescued from the second floor by firefighter Ed Convery, who received a citation from the department and a proclamation from the mayor in recognition of his bravery. This picture shows the remains of the building encrusted with icicles the next morning.

This tree has been proclaimed to be the fattest tree in Brielle; presumably it is also the oldest tree in Brielle. A plaque indicates the circumference to be 195 inches. This natural wonder is located on Osborn Avenue.

Each year at Brielle Day the Union Landing Historical Society steps back in time to sell old-fashioned soda. Sarsaparilla and other nontraditional soda flavors are sold in glass bottles by society members dressed in white shirts and bow ties. Pictured above from Brielle Day 2005 are (from left to right) Union Landing Historical Society past president E. David DuPre, Brielle borough historian and current president John Belding, vice president and chairman of the book committee Raymond F. Shea, and longtime society enthusiast Douglas Moore. Help is also provided by children's groups such as the Brielle Girl Scouts and Cub Scouts dressed in period attire pulling wagons hawking "ice cold sarsaparilla." Pictured below from left to right are 2006's Scout helpers Berit Walters, Indigo Shea, Alexandria Valdez, and Miles Shea.

Ed O'Brien, shown here in the white T-shirt, flew his whole family from his home in Colorado for the experience of fishing in the Atlantic Ocean. As a high school student, O'Brien frequented Brielle while visiting with his friend Richard Wurfel Jr.

Deep-sea divers John Chatterton and Richie Kohler discovered and identified a sunken German U-Boat 60 miles off the Manasquan Inlet. The divers' home port was Brielle Marine Basin aboard the *Seeker*, which is pictured here. This photograph of the *Seeker* was taken in the spring of 2001. The story of the discovery and challenges of Chatterton and Kohler's deep-sea adventures regarding the German U-Boat find is a nationally acclaimed book and is being made into a major motion picture.

The hill on the top of Rankin Road was once a final resting place of early Brielle area settlers, including some Revolutionary War veterans. Known as the Longstreet Burial Ground, it fell into disrepair and the site was eventually sold to a developer. Headstones and remains were moved to nearby Atlantic View Cemetery in Manasquan.

The Osborn Family Burial Ground on Holly Hill Drive was also overgrown and in a state of disrepair. Surrounded by borough-owned property, this area was protected from development or relocation. In 2000, a group of concerned Union Landing Historical Society members embarked on a restoration project of the graveyard. John Belding is the project coordinator and chief caretaker of the property. There are 28 graves, including Revolutionary War veteran Lt. Abraham Osborn.

After months of hard work, this is how the graveyard looked at the completion of the project in May 2001. The trees and brush were cleared, headstones were excavated and repaired, and a handsome iron fence was erected around the plot. Society members, other volunteers, and public works personnel all pitched in to complete the project. Financial support was provided by the Governor William Livingston chapter of the DAR. Annual Decoration Day events are held here hosted by the Union Landing Historical Society.

Following the events of September 11, 2001, society member E. David DuPre initiated a project to establish a suitable memorial to the victims from this area. With the permission of Mayor Thomas E. Nicol and the borough council, this site located at the intersection of Riverview Drive and Birch Drive was established as the 9/11 Memorial Garden. At the site's dedication ceremony, Brielle firefighter Ed Convery escorts Marilyn Rimmele to place flowers at the memorial. Rimmele's son perished in the attack. DuPre continues to serve as project coordinator.

Discover Thousands of Local History Books
Featuring Millions of Vintage Images

Arcadia Publishing, the leading local history publisher in the United States, is committed to making history accessible and meaningful through publishing books that celebrate and preserve the heritage of America's people and places.

Find more books like this at
www.arcadiapublishing.com

Search for your hometown history, your old stomping grounds, and even your favorite sports team.